*Contemporary Indian Sculpture*

THE MADRAS METAPHOR

# Contemporary Indian Sculpture

## THE MADRAS METAPHOR

*Edited by*

Josef James

MADRAS

OXFORD UNIVERSITY PRESS

DELHI    BOMBAY    CALCUTTA
1993

*Oxford University Press, Walton Street, Oxford OX2 6DP*
OXFORD   NEW YORK   TORONTO
DELHI   BOMBAY   CALCUTTA   MADRAS   KARACHI
KUALA LUMPUR   SINGAPORE   HONG KONG   TOKYO
NAIROBI   DAR ES SALAAM   CAPE TOWN
MELBOURNE   AUCKLAND   MADRID
and associates in
BERLIN   IBADAN

*Photographs by* Rm. Palaniappan
*Layouts by* Desh Designers, Madras 600 005

TYPESET BY IMAGES, MADRAS 600 017
PRINTED AT SUDARSAN GRAPHICS, MADRAS 600 017.
AND PUBLISHED BY NEIL O' BRIEN,
OXFORD UNIVERSITY PRESS, 219, ANNA SALAI, MADRAS 600 006

# Foreword

To the foreign viewer, or the curious layman in India, contemporary Indian art presents a scene bewildering in its complexity. So diverse are the styles, so varied the influences, that it seems almost impossible to formulate any concept or propound any thesis that would enable one to discern a homogeneity underlying the baffling array of forms jostling for recognition, even among a group of artists held together by a common ideology, or belonging to one specific region.

Modernism in the Western world is an issue that the Indian artist has had to contend with because, for better or for worse, it has had global implications. Modernism as understood and practised in Japan is certainly not the same thing as European modernism, because of the singular historical and cultural context in which it developed. And the same may be said of India which, like Japan, has a rich, sophisticated , ancient yet living artistic tradition. In actual practice, modernism is still valid in India and has not exhausted its possibilities, as it seems to have done in the West. Indeed, many kinds of modernism are still active, coexisting, as it were, in a variety of timeframes, in much the same way as do the heterogeneous cultures of the subcontinent. But a critique of modernism has not developed, for the hegemonizing role of museums, publications, and writing on art has not reached a sufficiently high level of intellectual discourse.

One is aware of a European critique of culture imposed on non-European cultures, in which the latter find themselves strait-jacketed by the very limits of the European experience. Part of that colonialism has been the emphasis on institutions and agencies in which culture is regarded as part of the world of commodities, rather than an indivisible part of a scheme of values beyond the purely materialistic. The spate of recent art auctions in India has shown how easy it is to throw out of gear serious explorations in the field of art, and to introduce the most meretricious and banal criteria in the evaluation of artistic creations. This has come about because the experience of contemporary Indian art has not been based on rigorous, clearly formulated

critical concepts, in which theme, technique, and pictorial or sculptural language are seen as part of an ongoing process in which tradition percolates into contemporary expression. There is a logic in this evolution, and it is the task of the critic and art-historian to discern how, why, and to what end artists have sought to depict their encounter with the contemporary world.

Impressionism, Cubism, Symbolism, and Expressionism have been as much part of the Indian artists' cultural heritage, as oriental art has been that of Matisse and Klee, or primitive art from Africa and Oceania that of Picasso and a whole host of European painters and sculptors from the early years of this century. The rounded sculptural forms of nineteenth century Kalighat painting owe nothing to Fernand Leger, and are not legitimized into 'modernism' by the resemblance of Leger's works to them. And the wiry, elongated metal sculpture of Bastar anticipated Giacometti by several centuries, and deal with a much wider range of human experience than the angst-ridden works of the modern master.

A distinction needs to be made between the 'derivative' and the 'assimilated', between 'imitation' and 'recognition'. The patronizing and dismissive attitude of Western writers on contemporary Indian art, and their intellectually servile Indian counterparts is based largely on colossal ignorance, and a narrow, almost myopic view of art masquerading as superiority. For the mind and sensibility of the Indian artist are extremely sophisticated and subtle, and nurtured by a view of life that is deeply and searchingly spiritual. For the authentic Indian artist the very practice of his vocation is indeed a form of yogic discipline for his own spiritual salvation. He refuses to participate in the loathsome rat-race to pander to the whims of dubious manipulators.

The 'packaging' and presentation of art leaves much to be desired by current international curatorial standards. And the banal series of exhibitions organized by Indian officialdom have done it signal disservice. But the artists themselves are not to blame for this. Their honesty and dedication in the face of fearful odds, and their singular creative achievement in the midst of a society that is slowly succumbing to the crassness of Western outlook, will ultimately come to be seen for their essential worth.

Dr Josef James's thoughtful, erudite, and sensitive study is one large, significant step in that direction.

London
8 July 1993

Ebrahim Alkazi

# Preface

Contemporary Indian sculpture has been surveyed in some detail and its range and variety noted. See, for instance, *Indian Sculpture Today - 1983* published by the Jehangir Art Gallery, Bombay. Perceptive presentations of the work of important sculptors have been made by the Lalit Kala Akademi and noted galleries like Art Heritage, New Delhi. I am indebted to both these kinds of studies, but this work is neither a survey nor a biographical presentation of contemporary Indian sculpture. It is an attempt to scan a particular body of work for what might be distinctive about contemporary Indian sculpture in general. Quite frankly, once undertaken, the task did appear much larger and more complex than I had bargained for, but a beginning must be made somewhere. I have done that by seeking to unravel the historical and social background, theoretical premises, and technical factors that may have contributed to the development of this unusual body of work. Such a study, I believe, will provide some insights into the theoretical underpinnings and practical directions in which contemporary Indian art is moving and provide some answers to its whys and wherefores.

It is possibly the underlying theory or technique which makes a work distinctive, especially if it proves to be unique to that particular work or to that particular kind of work. That basically has been the premise on which I have approached the subject. Theory is possibly a bald term under which to group works of art, but I use it only as shorthand for the underlying philosophy or at least technique. That, it might still be argued, would be to ignore the emotive forces, the motivations or the expressive urges that have gone into the making of contemporary Indian sculpture. If that were indeed so, my approach would certainly not have got anywhere. Such forces, motivations, and urges I believe are precisely the ones which evoke a particular theory or technique. In the underlying theory we therefore have a sharp and continuing reference to the basic inspirational force.

The first draft of the book took the form of an illustrated talk I gave in Bombay in February 1991 at the invitation of the National Centre for the Performing Arts. It was elaborated and publicly documented by a major exhibition of sculpture which The Art Heritage sponsored in Delhi in December

that year. From then on it has taken nearly two years to put it together in book form before a larger public for discussion and assessment.

I was helped in that effort initially by the sculptors who lent their works for the Art Heritage exhibition. The Lalit Kala Akademi, New Delhi, and the State Akademi, Madras encouraged us and funded us, as did some of the major industrial houses in the country. Many helped with their labour and time in the preparation of the texts and in so many other ways. To all of them I remain grateful. I am grateful also to the Lalit Kala Akademi for giving us permission to use photographs from its archives. Editorial comments and criticisms from Oxford University Press have helped to improve the presentation enormously. We thank them very specially. For the errors that remain and other shortcomings, I own all responsibility.

Cholamandal Artists' Village
Madras - 600 041
22 August 1993

Josef James

# Acknowledgements

We gratefully acknowledge the help readily given to us by many in producing this book. Of them we like to mention the following whose help at various stages had been crucial.

Lalit Kala Akademi, New Delhi;  MRF Ltd., Madras;  Tamil Nadu  Oviam Nunkalai Kuzhu;  Audco India Ltd.;  Alsa Group of Companies ;  Chemicals and Plastics India Ltd.;  Sundaram Fasteners Ltd., Madras;  Parry & Co. Ltd., Madras;  Indu Goenka;  Abhishek Poddar;  Sarala Art Centre, Madras;   Heritage Gallery, Madras;   K.P.V. Nair, India International Centre, Calcutta; Onload Gears, Madras.

# Contents

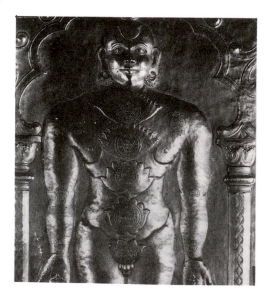

'The Human Body as Yantra'
Copper with Gold Wash
South India
18th Century A.D.

'Vishnu as the Cosmic Boar'
Granite
Balsane, South India

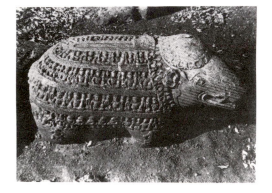

# Contemporary Indian Sculpture - The Madras Metaphor

Sculpture, of all the arts, has the longest history in the Indian subcontinent. The earliest known instances of it are figurines belonging to the Indus Valley civilization nearly four thousand years ago. The distinctive type of workmanship that went into these prehistoric pieces of sculpture has been exposed subsequently to many influences and undergone myriad transformations, giving rise to a great body of sculpture in this historic region. This artistic development is believed to have come to an end in the eighteenth century. During its exceptionally long efflorescence, it spread to widely disparate parts of the subcontinent: Punjab, Uttar Pradesh, Andhra Pradesh, Bihar, Orissa, Mysore, and Tamil Nadu. It gave rise to local metaphors embodying, in its wake, the essence and characteristic forms of the region. However, in the South, its original prehistoric sculptural spirit seems to have persisted, as is evidenced by a few technical devices which, according to some observers, link it somehow to the Chola bronzes of the eleventh and twelfth centuries.[1]

That often florid passage of sculptural expression through millenia and over different parts of the subcontinent is what is reminiscently thought of today as being the great tradition of Indian sculpture.[2] Its spirit is generally believed to have run its historic course by the eighteenth century and there has been no evident sense of life in it since the architecture and art of the Nayak period of the Hindu kingdom in central Tamil Nadu. That ought to mean that the spirit of the movement had reverted by that time to the routines and beliefs of common life that had sustained it upto that point in the history of the subcontinent. British conquest and the establish-

ment of their rule created a situation in which the ideas and methods of European art began making inroads into the indigenous tradition of art and life, thereby multiplying the odds against its continuation. That led naturally to the destabilization of the composite culture of the subcontinent, of its native economy, and the sense of historic tradition that had nurtured them for so long.[3]

This was not, however, India's first experience of cultural destabilization, nor was it abrupt. In the eleventh and twelfth centuries, when the great Chola bronzes were being cast, the Bhakti movement brought in its wake a wave of protestant spirit, which displaced the great critical schools of Buddhism and Jainism in the Tamil country. It spread from there to the North, extensively unsettling the entrenched vedic religion and outlook. What started as devotional cults as early as the sixth and seventh centuries in the Tamil country, soon found their theologians and philosophers who raised the early expression of the spirit from its cultish phase to mature belief and a systematic world-view. Ramanuja, the foremost of them, was a Tamil Brahmin who taught in the eleventh century (at the famous Sri Ranganatha Temple) at Tiruchchirapalli in central Tamil Nadu. He systematized the strong theistic feeling of the early devotional cults and preached a God of love, grace, and

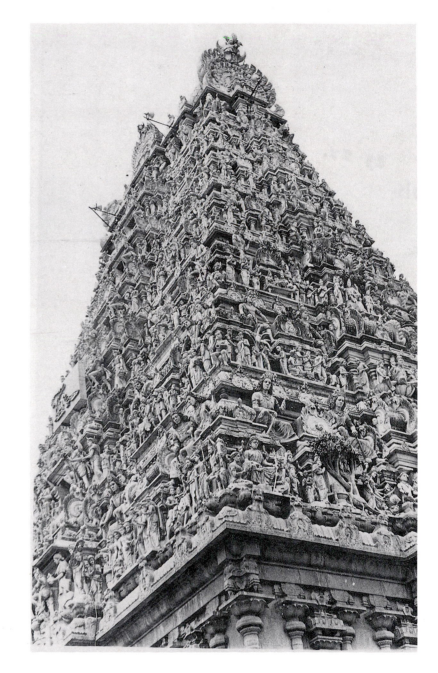

forgiveness. He upheld the individual being and stressed personal relationship with God. Madhva who followed him was a theologian from the Kannada region. He advanced Bhakti theology further, dismissing vedic spiritualism and upanishadic monism, preached a God of grace, the legitimacy of human reason, and the sanctity of moral living.

In its stress upon theistic foundations as against that of an eternal order (Sanathana Dharma), upon the individual being as against caste and the migratory soul, upon love and forgiveness as against the rule of predestination and causation (Karma), and upon rationality against ritualism, the movement was assertively heretical. It spread extensively, especially among the lower castes and raised searching social questions.[4] The foundational values of the movement had much in common with the Western religions—Islam and Christianity—and by extension with those of Western Englightenment.[5] India had thus, starting from the South, been confronted and come to terms with the idea of theistic religion, humanism, and rationality much before the colonial administrator had set about his mission of enlivening indigenous thought and imagination with 'the power of European art'.[6]

Bhakti saints , from the Tamil hymnists of the sixth century upto Kabir and Nanak of the fifteenth century in the North, had moved the basis of

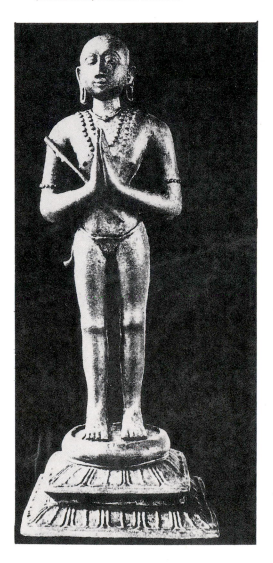

'Appar'
Early Chola Period
11th Century A.D.
Bronze
Polonnaruva, Colombo Museum

thought and being from the object of worship to the idealization and moral fervour realized in the act of worship.[7] One after another they contributed to the creation and spread of an intimate, humanistic vernacular. Those whom it liberated, chiefly from the lower castes and from amongst traders and artisans, formed the nascent middle class which in modern times found its Mahatma, politicized social reform, and through popular movement led the country to independence and twentieth century modernism. In the arts the rejuvenation was not as catalytic as in the political sphere, but no less historic. In music, for instance, the Bhakti spirit expressed itself in exceptional feeling and refinement by the eighteenth century and is reckoned to have brought about in the South the Golden age of Carnatic music, which extended well into the nineteenth and early twentieth centuries.[8] In prosody the new spirit had manifested itself resoundingly much earlier.[9]

Significantly, the native Bhakti response to the rejuvenating, liberal value of Enlightenment proved problematic in the visual arts: painting, sculpture, and architecture. Here the impetus of the older traditions seem to have lost their momentum in the eighteenth century and failed to find new inspiration from the ideas sweeping the country, as did the more abstract arts like music and prosody. An inquiry into this question, especially in relation to sculpture, could serve as preface to the study of Indian sculpture in its extension into modern times. Such an enquiry could benefit also by examining painting of the corresponding period because it appears to share with sculpture the larger predicament. The predicament must have caused considerable frustration generally, but in the South, where the tradition had sustained itself longer than anywhere else, the feeling of frustration must have been deeper and sharper. It would therefore be useful to bear this particular situation in mind in the course of the enquiry.

Music, which in contrast to sculpture and painting had sustained, and indeed strengthened its tradition, is certainly the most abstract of all arts. It is not made up of any material substance. It cannot be made to represent or bear likeness to any object or being, nor does it ever become a material object

▽ Pilloo Pochkhanawalla
'Composition'
Bronze

▽ Adi Davierwalla
'She and Three Others'
Welded Steel
1965

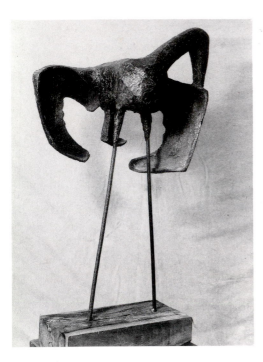

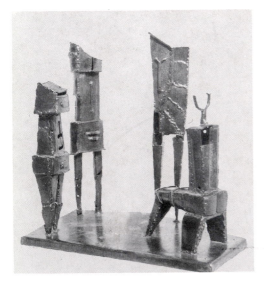

itself in a world of material objects and being. That goes for literature, although perhaps less conclusively. The resources and means needed to create a work of music are therefore entirely of the mind and of the spirit; the material sciences and technology which determine the world of objects have scarcely anything to do with the activity of bringing it into being. Resources of the subtle sort of which it is formed are to be found in the rich store of 'religious technology'[10] with which the indigenous tradition is handsomely endowed. Had it not been so, music, speculative wisdom, and mathematics could not have attained such heights or persisted for so long in the indigenous culture. In these areas, therfore, ideas from outside found much to contend with and to absorb before being able to influence in any way the long-established tradition. The fact that at least in the case of music the West has received much more than it has given testifies to the stability of exchange in that area.[11] It could be argued that this holds true, more or less, in the related areas of prosody and dance.

In the case of sculpture and the other visual arts in the subcontinent, the wealth of subtle means in tradition cannot by themselves stand for much in the contemporary world. These arts are materialistic, in an empirical sense of course, since they are made of materials. Expression in these media must necessarily assume a material body and in the ultimate analysis have to stand or fall as objects in the real world. That status accorded to works in the visual arts make them belong incorrigibly to the Galilean world of Western science. The issue is compounded if, in the making of sculpture or painting, any kind of mirroring of the real world of space and time is involved. These aspects of expression open out their mystique to the rule of scientific objectivity and in turn to the sceptical values which prop up such a view of the world. The 'brave new world' in which such works of art are evaluated, is one in which reason is the rule and sense verification is final. Tradition, for all the richness and sophistication of the metaphysic that it embodied, found little to contribute to such a world of material ends and means.[12] That being the case in

the early years of this century, it offered virtually no ideological underpinnings to Indian sculptors and painters.

As traditional work in these media became routine, mechanical, devoid of inspiration, and repetitive, sculptors and painters sought stimulus in Western art which forced them into the new world of rationalized objectivity. The early results of their excursions were non-committal in mood and at best only emulative.[13] And that, apart from everything else, speaks of a kind of 'Dubashi' commerce in culture which arose characteristically in a colonial port city like Bombay in Maharashtra. Fifty years later, for the sculptor Pilloo Pochkhanawala of the same city, it was no longer a trade. 'The age of tradition is dead', she proclaimed without any feeling of regret. She felt herself to be enirely on her own with her genius in the great renaissance tradition of Western art, to be carried along by the excitement of the raw edge of experimentation.[14] In her sculptures, which were remarkably true to that spirit, it was as though a tradition of Indian sculpture had never really been.

Candid personal certifications like this multiplied and the posture gained ground.[15] It was tempered, broadened, and institutionalized by Sankho Chaudhury, sculptor, teacher, and administrator from the city of Calcutta. Schooled at Shantiniketan, where a

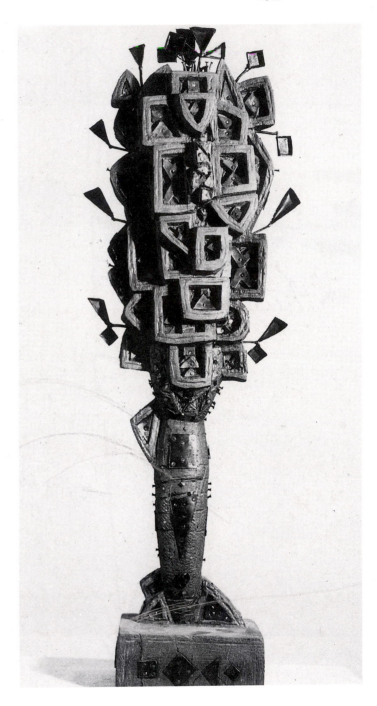

Dhanraj Bhagat
'Musical Construction'
Wood and Steel
1967

group of painters were initiating a move to resuscitate the historic tradition, the sculptor found the Western discipline more suited to his intellect and purpose. The studies he made of it, with an open, professional mind, left him with the bare material norms arrived at by the more recent sculptors in that tradition. He concentrated on the sheer profession of sculpting in material, in line with the unclouded insights of Western abstractionist sculptors. Cultural influences were valid only, according to this attitude of openness, if they were professionally motivating and in accordance with work norms that could be clearly enunciated.[16] Besides exemplifying this exacting principle in his own sculptures, he found himself in a position to institutionalize it in the course of setting up and administering the department of sculpture at the M.S. University at Baroda, in Gujarat. This attitude of unsparing professionalism and studied neutrality made a fair case for abstract sculpture in the country around the middle of this century.

The abstemious attitude and the open outlook which it fostered proved to be more reductive than the abstraction it effected in sculpture and painting. It led to a total abandonment of imaging or mirroring in these arts on which the logic of Western epistemology and science had placed their claims to truth.[17] In the plastic arts, the same development led to a perilous

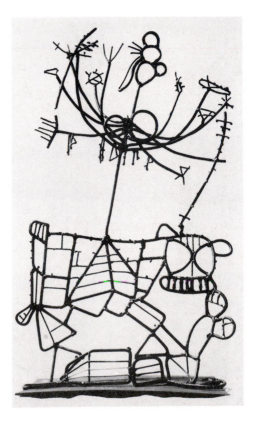

Dhanraj Bhagat
'Cosmic Dance'
Welded Steel
1967

loosening of definition and eventually to the dramatic opening up and dematerialization of sculpture abroad in the postwar period. The thrust of this drastic progress was to relieve sculpture of its material body and thus to confound its status as a physical object of observed size, shape, surface, density, and location.[18] The move clearly was towards a sculpture which was more a thing of the spirit, a matter of subtle perception, a sense of something unspecifically present somehow than the body of substance it had been taken to be earlier in that tradition.

The first among Indian sculptors to have sensed this possibility after the abstractionists abroad had realized it was Dhanraj Bhagat of Delhi. He did not, however, stop for the fair deal of abstraction nor for the stolid work norms, but experimented spiritedly with methods and materials, seeking after 'the essence of one's feeling', as he delicately put it.[19] Values, norms, and techniques are valid only in so far as they were warranted by feeling, he believed, and were not prescriptive nor prior to the artist's expression of it. In that spirit, he carved the weight away from his sculpture to bring out a light pictorial feeling. His work turned interestingly notational in mid-career, picturing from then on the fine unspecific feeling in rare spatial forms. In those sculptures he was clearly in line with the sculptors abroad who had worked to render sculpture open and spatial.[20] The development abroad must be seen as an attempt to make sculpture open and yet somehow 'rational' by making most of it over to space which, according to Kantian epistemology, is at least one of the coordinates of rational, cognitive experience.[21] While that left the concept of open, spatial sculpture as sculptors in that tradition worked it, still deeply Western, Bhagat was able to breathe with it, and in and out of a different universe of discourse altogether. His work introduced the possibility of creative cross-cultural ideation and sculptors after him, who owed this to him, explored it much farther.[22]

As Bhagat pursued such openness in his own work, crafting it finer and finer, a highly evolved metaphysical feeling of form began to take over his work. It titled itself variously as

▽ 'Rajnikant Panchal
'Tonga'
Cast Bronze

▽ Prodosh Das Gupta
'Reclining Eggs'
Electroplated Bronze

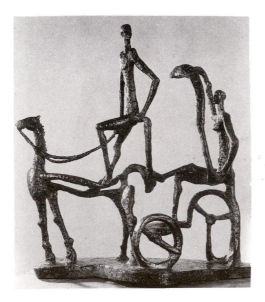

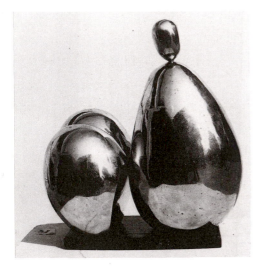

'Bull'(1952), 'Tree of Life'(1953), 'Shiva Dance' (1956), 'Flute Player' (1958), and the 'Third Eye'(1962). The unspecificity was gaining a positively metaphysical articulation as a whole school of sematic specifications began surfacing in his work. 'It is, perhaps, of a spiritual nature', remarked Bhagat, reflecting on this unexpected development.[23]

Such opening and figuration which began to appear in contemporary Indian sculpture from the late sixties would not have been possible at all had the weighty and pressing edge of the Western world-view persisted. As it happened, the secular and science-centered outlook that had given it power and dominion could not for long sustain that role.The contention that the physicality of the world and of being is its conclusive reality, had apparently lost credit in the very culture that had given it birth.[24] With that argument lost, the culture which had stood on its strength forfeited its edge and found itself at par with the traditionally ambivalent indigenous ones it had colonized and overrun. In the case of the visual arts, notably in sculpture, the hard grip of physicality which it had sought to impose could no longer hold once it had lost the case for it in its own domicile. By the late sixties, when this became evident, it was as if the 'power of European art with which the Indian artist could render Indian mythology and life' had never really been.

But this appeared to have happened too soon in Dhanraj Bhagat's work. The figures which had started to appear in his work were turning into images, not of anything real any more but of some self-certifying subjectivity which was weirdly powerful and confining. Obviously, some of the 'religious technology' stored up in tradition was at work but uncontrollably at this stage, giving his sculpture an introverted, cultish appearance. That presumably made him shrink from it, as his few final sculptures show.[25] The issue was not just with the oppressive rule of scepticism and objectivity but equally with the hold of self-certifying and self-serving subjectivity which could perhaps be just as confining. This dilemma in which the sculptor found himself had been encountered earlier, notably in the early years of the Bengal movement.

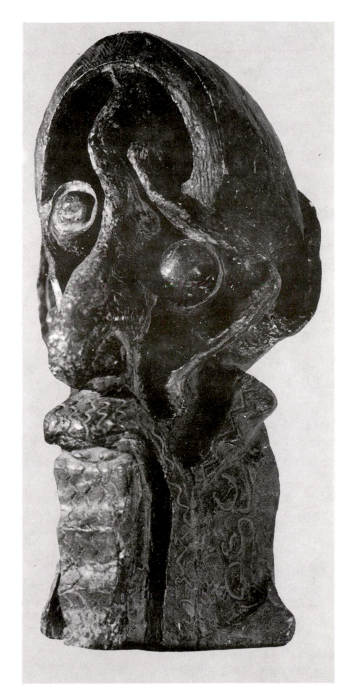

▽  Ramkinkar Baij
   'The Poet's Head'
   Plaster of Paris
   1938

The sculpture of the Bengal movement[26] was a polemic in the spirit of the Impressionists abroad against the deadening definition of Western classicism.[27] The Bengal sculptors trained it on the indigenous subject in its mundane manifestations in the manner of the Impressionists who had chosen the common and the unheroic to register their protest. The Bengal exemplification of it was historically the first essay in the expression of a humanist spirit in contemporary Indian art but in the well-worn Western mode of protest. The violence of it should make one see that the artists were not in a position at that stage to debate the issue they were attempting to raise with the culture in which they would have it domiciled. They were at that time content to merely assert its premises.[28]

The humanist search 'towards a maximization of expression and communication' in the sculpture of Ramkinker Baij of Bengal had led him, understandably, to 'a charged preoccupation with the image itself rather than the process of working'.[29] It had obviously stood in his way in sensing the radical potential of the workmanship he had hazarded in his sculpture.[30] His workmanship spells out a powerful rhetoric, indicative of a sculptural 'text' into which the image and its presence could be deconstructed.[31] The rhetoric is the agent that communicates the subject or whatever there

is to be communicated; it is finally the expression of what is sought to be expressed. Until that insight was obtained, sculpture had to stay loaded with the dense body of the subject and incapacitated for that reason from debating the native tradition of highly abstracted workmanship, or the tradition itself.

Madras in the South is the third colonial port city where painters and sculptors gathered in search of ideological standpoints and arguments. One is never too far in this city from the past, for it is elaborately present on almost every occasion in peoples' lives. In the common culture that rules the city and the region lies sedimented much of the craft, circumspection, and artifice of the great systems of thought, industry, and expression that had flourished over it in the past. It was from this culture that apprentices were drawn to be trained in the Madras School of Art and Crafts after its establishment in the city in 1859 by the colonial administration.[32] Their brief was to excel chiefly in the creation of art goods[33] until Devi Prasad Roy Choudhury, the renowned sculptor from Bengal, took charge of them as Principal of the School in 1929. A number of artists from the Bengal movement joined him at Madras, as did some from the neighbouring states of Andhra Pradesh and Kerala.[34]

The Madras School of Art and Crafts, which consisted of a group of

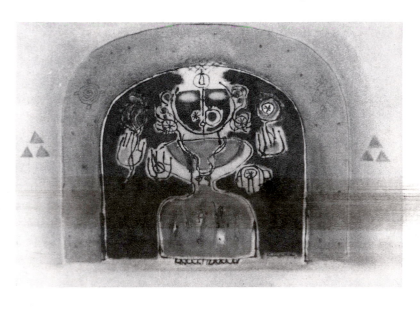

▽  K.C.S.Paniker
    'Words & Symbols'
    Oil on Canvas
    1976

▽  Kanayi Kunhi Raman
    'Fertility'
    Concrete
    1971

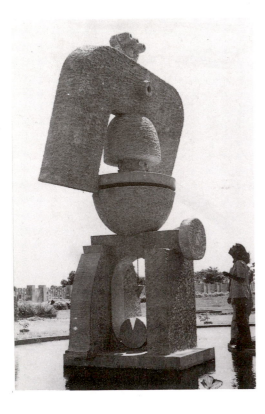

joined with individual intuitive perceptions. Painters at the Madras School had seen the possibilities ahead of the sculptors and had set themselves to the task as a group under K.C.S. Paniker who took over the reins as Principal when Roy Choudhury retired in 1957.

What the Bengal movement conveyed to Madras was essentially the spirit of the attempt abroad to defy the deepset, rounded definitions of Western Classicism, edged with, of course, the earnest plea to scour non-Western traditions for alternative methods. The fresh approach of the Impressionist painters who had initiated the movement abroad came through very well as the Bengal movement came under close technical scrutiny.

A great deal of expressive colour came through along with some open-ended theorization regarding pictoral figuration, and it moved painters in Madras as it moved leading painters all over the country. But few in the fifties suspected that the situation carried within it the potential for a radical development leading to the discovery of fresh premises for contemporary Indian art.

For indigenous craft-minded considerations, the liveliness and control in Impressionistic painting lay not in its body of colour but in the sensitivity and circumspection of the rhetoric with which the colour was laced. That was an unusual perception considering the appeal of the sheer colour in those paintings. But that was precisely the direction which the Madras painters[40] took in pursuit of that rare sense of life in pictorial expression. They searched for it in the whole body of colour and sensed it in the scatter of rhythms impregnating and enlivening their paintings.[41] In their own work the Madras painters drew it finer and finer, sensing it with increasing precision until it turned into an elaborate figure of itself, as in quality craftwork.[42] Their drawing turned algebraic, severely notational, or calligraphic, and well in line with the tradition of indigenous drawing.[43] Pushing it to the limit they finally arrived at the perfectly open form, obliterating in their argument depths and roundedness of all kinds.[44] That settled, as far as they were concerned, the Impressionist's agitation

on that score. This went much beyond what the Bengal movement envisaged; a new metaphor had taken over.

This radical development, one might conclude, was the work of the live craft-sense implicit in the work of the Madras painters. They had themselves underlined the basic role of this subtle agent in the art of picture making and tersely theorized about it.[45] It would not suffice to say that such a sense was habitual, arising out of a long tradition of workmanship. The critical acumen and circumspection behind it was exceptional. They were suggestive of depths and connections, both of which looked far-reaching.

As early as the second century Buddhist logicians in a brilliant argument demonstrated the logical impossibility of knowledge and thus of objects of knowledge and of objects in general.[46] Such refutation, the Nyaya philosophers of the fourth century countered, must in principle refute itself.[47] These two positions taken together point to a subject or illumination which one cannot speak about, picture, or describe without turning it into a being or a state that cannot possibly exist.[48] Critical sense trained in these arguments would cut through objectification of all kinds including creations of imagination and fancy. All that it might concede in an expression would be the rhetoric, the craft, the total disembodiment or illumination. The mystic finish, when the Madras

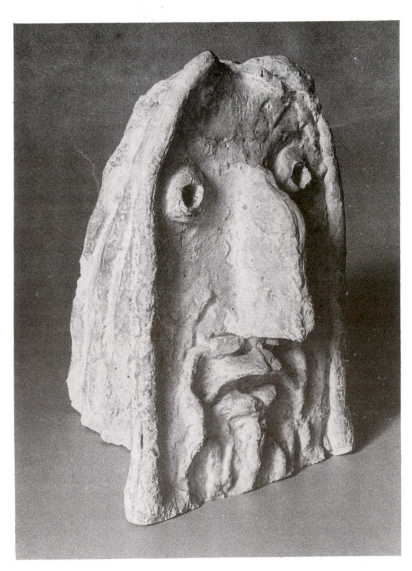

▽ 'The Sole of Buddha's Foot
   in Nirvana'
   Thai Origin

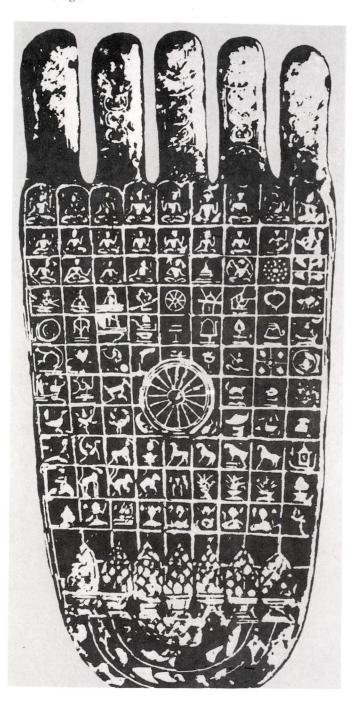

painters finally effected it, looked surprisingly familiar. It was precisely of the kind one sees in traditional work, be it craft, sculpture, architecture, music, or even ritual. It made the workmanship in all these areas look surprisingly contemporary and excitingly resourcesful.[49] It is not therefore surprising that the individual to make the first move towards clarifying sculpture was a Sthapathy, a traditionally trained temple sculptor. After a strict schooling in the traditional disciplines, Vidyashankar Sthapathy was brought to the Madras School of Art and Crafts by his father and mentor, an eminent Sthapathy himself. At the school he had only to draw upon his knowledge of traditional work in sheet metal to follow up a suggestion in the work of S. Dhanapal, his teacher at the Madras School, to initiate a radical movement in sculpture.

His sculpture in flat sheet metal dispensed altogether with the rounded definition and rid sculpture of its characteristic body of material substance. It demonstrated that articulation in a work of sculpture can be abstracted into surface relief and totally freed of any body of substance or material extension. It was clearly an extension into sculpture of the technique of relieving an expression of its weight of objectivity and epistemic content, which his painter colleagues at the School had developed.[50] The surprising thing was that it took very little

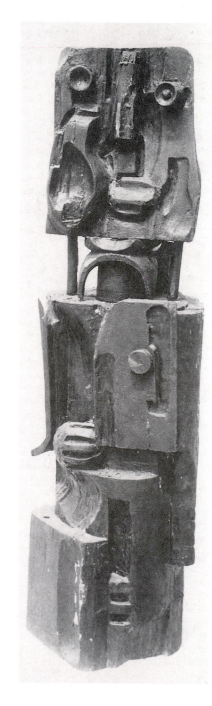

▽ Anila Jacob
'Image'
Wood
1965

else other than Sthapathy's mastery of traditional metal-work to effect something so contemporary and controversial.

Criticism of the notion of bodied sculpture and attempts to modify it had, in fact, started earlier in Madras. It began with some highly suggestive extensions of modelling in Dhanapal's work. But the notional release from its body of dense substance was first effected by Kanayi Kunhiraman, a student of Dhanapal and fellow sculptor of Sthapathy. He started with highly poetic expressions in stone and cement and advanced into a sculpture 'which touches the earth, spreads in it, and grows from it in the visual plasticity shaped out of the mystery of the inside'.[51] The possibility of making sculpture that was entirely frontal was suggested in the wood sculptures of Anila Jacob. But it was left to Sthapathy, working in sheet metal, to reduce it finally to a surface and to make it weightless, in the way picture surfaces notionally are.

It cannot be argued that this development in sculpture took place according to pre-determined plan. The fairly long-drawn out journey towards abstract sculpture advanced through a series of significant and catalytic contributions by key personalities in a historic attempt to get on a level with the methods and aims of traditional sculpture. The whole point of traditional workmanship, it can be argued, had been to abstract the surface from the material that one starts with in order to make sculpture. It should not be difficult to visualize it handled as if it were a free agent, modulating, inflecting, and accenting itself with flourishes of ornamentation and en-livening detail as in traditional sculptural figuration.[52]

Sculptors in Madras seem to have been directed by an in-tuitive feeling for workmanship of that order as they carved and modelled until sheet metal surprised them with exactly the kind of surface that is present traditionally in rare and weightless sculpture. With their intuition ascertained, they went on to try out some of the exceptional effects that tradi-tional workmanship had wrought with it, chiefly, that of pic-torial figuration. The first and foremost among those to at-tempt this was P.V. Janakiram, a student of Dhanapal who succeeded him as the instructor in sculpture at the Madras

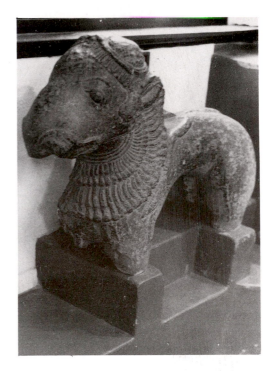

▽ 'Yali'
Granite
Bellary District - Karnataka

School of Art and Crafts. In a series of sculptures starting from 1964, Janakiram reduced sculpture to a flat, frontal aspect, and brought on to it, with a master craftman's skill, the free surface, the modulations, inflections, the ornamentation, enlivening detail — in fact, all the basic means of pictorial figuration in traditional sculpture. His work looked pictorial like traditional work but terse with a contemporary rigour.

Janakiram worked in welded sheet metal and his large and sustained output established welded sheet metal as the medium for the new sculpture. This medium, as it happens, had been well-established in Western sculpture by that time. It was indeed work in this medium that had 'opened up' sculpture abroad where a contemporary tradition had developed over five decades.[53] It was then safe, in a sense, for the Madras sculptor to have experimented with new sculpture in this medium. His work also involved 'opening up' of a sort or at least some 'cutting through', as had been the case with steel sculpture overseas. But given the native tradition which had expressed itself in this sculpture, it would have seemed more natural for sculptors here to be drawn to materials like stone and terracotta in which a considerable body of traditional work had been done.

Two sculptors, C. Dakshinamoorthy and P.S. Nandhan, both fellow-sculptors with Janakiram at the Government College of Art and Crafts, Madras worked in terracotta and stone. The sculptural sense that was being refined in that institution had made them curious about surfaces created through hollow modelling in terracotta, its earthy quality, the possibility of animating it through colouring and marking — all of which are skilfully exploited in traditional workmanship in the medium.[54] These two sculptors were inspired to use these special work possibilities to carry sculpture beyond its shape or shapeliness, in the way that Janakiram had worked sheet metal. Nandan made a series of masks in terracotta, skilful executions in free surfaces, open, airy, and decidedly frontal. Dakshinamoorthy's grouped figures in this medium and in stone abstract themselves into patterns, notionally open and freely found. Much was to be made of this idea in

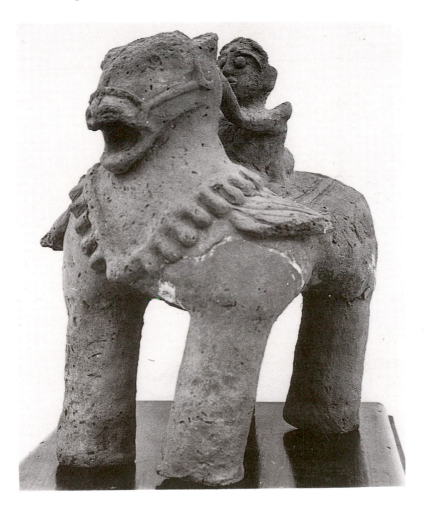

'Winged Horse'
Terracotta
Ennore, North Tamil Nadu
Folk Origin

later development of sculpture in the Madras School.

S. Paramasivam, one among the younger sculptors, had started as a painter but joined with the sculptors and entered the argument. He started out boldly, shaping with sheet metal, punctuating the rounded image with ornamental details. In these and in his later schematic expressions in the same medium he had remained critical of frontality which was emerging as the principal idea in Madras sculpture. Frontal sculpture, such as that Vidyashankar Sthapathy, Janakiram, and Nandagopal were establishing, for all its clarity and power of unmediated address, was burdened with a rear which was decidedly unsculptural. If the frontal aspect was to be the complete sculpture there should be a way of doing away completely with the rear end, he seemed to have contended, and tried to rethink the design and suspension of the work. Critical view of frontality, of medium specificity and professional reservations at various stages, together with the radical progress of the idea gave the venture the appearance of a movement, not perhaps in consensus but in controversy.

It 'opened up' sculpture, so to say, and moved it out into the open, putting it, it would appear, into line with a well-established tradition in contemporary sculpture. Its sharply controversial nature, however, be-

▽   K.Ramanujam
'Dreamland'
Ink on Paper
1972

trayed no disposition to break out sensationally into an 'anarchist freedom with materials',[55] 'a play of incongruities,'[56] 'a cryptic and often ferocious poetry',[57] or into being 'both helpless and scary',[58] as had been the tendency with the open form abroad It suffered from no terminal feeling of hopeless irresolution which make workmanship of any kind seem ultimately pointless.[59] The open form advanced by the Madras sculptors, on the other hand, was resolute and subtly detailed with spirited workmanship. The innate craft-sense enabled them to make the sculptural expression vividly notational, as in Madras painting, antecedently and essentially employing the same epistemological argument.[60]

The exceptional pictorial possibilities with calligraphic craftsmanship had been excellently demonstrated by the Madras painters by the late sixties. Such possibilities were implicit in the frontal sculpture of Janakiram and they were boldly advanced by Nandagopal, the youngest sculptor in the group. Janakiram's severe editing of the traditional finish in surface and decorative flourishes had reduced sculpture to a more or less flat, free-standing relief. Nandagopal had only to relieve it of it's highly restrictive figurative aspect to see it essentially as an open 'text' of notational devices. After demonstrating this possibility in his own work in welded sheet metal, the young sculptor went on to create

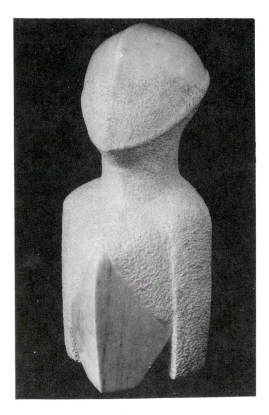

Nagji Patel
'Pink Bust'
Marble
1976

explicitly open sculpture in vivid notation. With that move sculptural expression turned decisively away from the received contemporary modes, breaking away from the philosophy of perception that had been basic to the Western approach to sculpture. The move had behind it the strength of a rather elegant argument and elucidation in the traditional discourse on logic. The Buddhist argument demonstrating the logical impossibility of objectification and its partial refutation by the Nyaya philosophers had led to a method of definition or specification being devised that did not involve objectification, except perhaps with extreme subtlety.[61] It defines or specifies in terms of *lakshana*s, or characteristic traits or qualities. The definition would consist of 'the collection of all the required causal conditions leading to the perception or cognition of an object minus the object in question itself along with any other thing concommitant with it'.[62] It corresponds loosely with intensional definition in standard Western logic and contrasts with extensional definition in the same discourse.[63] Western logic and epistemology favours extensional definition : a definition in terms of class as against that in terms of qualities, keeping the discourse within a framework of objectified reality.[64] That had been the condition of rationality that has characterized artistic expression in that tradition, and pointedly in sculpture.

The movement, extending up to the work of Nandagopal, had been an intelligent attempt not just to subvert the hegemony of that particular methodology and tradition on contemporary Indian art but also, and more importantly, to substitute it with an extended discourse founded upon the resources latent in traditional thought and sensibility. It was aspects of the traditional technique which came into view at successive levels of understanding that advanced the effort extending to the work of Nandagopal, at which point the technique itself seemed to have taken over to relieve the expression of its straitening dependence. Sculpture at this stage of development did not objectify any further but apprehended through a process of free scanning and crafty detailing, the unbodied subject. The workmanship consisted of

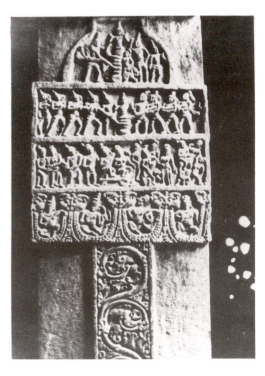

'Churning of the Ocean'
Granite
The Temple at Pattadakkal
South India

conjugating the *lakshana*s or the characterizing marks variously into patterns until the work got seized and turned into spirit, as is known to happen in exhaustively ritualized executions. Descriptive patterning with its capacity to intensify and illuminate was the principle of Nandagopal's work.[65] An objective assessment of his workmanship with patterns can make it appear merely decorative,[66] but patterns with generative grammers of their own have been shown to make at least good mathematical sense.[67]

The objective consideration, where it persisted, has been generally incapacitated by the dramatic breakdown of its supporting epistemology.[68] The limits to which it could be driven and its disasterous breakdown at that point has been exemplified by 'both the courageousness of what the Abstract Expressionists tried to do and the enormity of their failure'.[69] It got riddled thereafter, in the Western tradition, with a 'kind of conceptual warfare so intense and unresolved', 'that art today in that culture is just destabilization owing its continued existence to the memory of boundaries no one can any longer respect'.[70] Sensational attempts to break out, as the Abstract Expressionists first sought to do, led them to finish up in exile 'at the vortex of despair which they could never satisfactorily depict'.[71] That has been the kind of fatal indulgence that the discipline has inherited from its sensational progress abroad.

Such a denouement is no longer in prospect in contemporary Indian sculpture. It has been possible for at least one school of sculptors to realign the discipline technically with a tradition in which the disabling bind of objectivity had been systematically eliminated. The objective consideration in that tradition counted for no more than a practical understanding of the materials and tools and the constraints such understanding placed on workmanship in each case. It left them with much that could, in principle, be satisfactorily depicted, given the materials and tools, without being prevented by some ideologically fixed absolute limits of perception. They had to work their way into the indigenous tradition of expression, learn of its workmanship, and advance with it on their own in order to go beyond the limits set by conceptual

▽ 'Cosmic Energy Symbolized as
the Serpent Power'
Wood
South India
18th Century

arguments. Their technique shone through clearly, according to a discerning critic, in the 'expressive manipulations and transformations of traditional forms and meanings and in its extraordinary visual richness'.[72] The bind was no longer holding them down if that could be a description of the spirit of their work. Contextualizing it, a senior critic, an interpreter of tradition, and one who had watched it negotiate the weight that the West had cast upon it, noted in the Metaphor 'the deeper realization of the subterranean currents of our age of transition'.[73] But his summary description of it as shadowing a 'delirium of the human soul'[74] puts it in a precise cultural perspective.

That state of maximal being which the critic discerned in the Metaphor is remarkably suggestive of 'the spontaneous play of creative consciousness',[75] which is how Bhakti or the worshipful union with the Unknown is traditionally perceived in indigenous culture, especially in the South.[76] That is the transport that the mystics and saints through the centuries had sung about in different parts of the subcontinent and is modestly echoed in the routine of devotees and of the common folk in their different trades. That has been the kind of confirmation that awaited the Metaphor as it attained its maximal state. To make such a state of being an object of thought would be to externalize it, to detach it from the subject, and lose it

# Notes and References

1.  'The violent coaxial dislocation' or 'the extreme wiry attenuation'. Benjamin Roland, *The Art and Architecture of India — Buddhist, Jain , Hindu,* Pelican History of Art, Penguin, Harmondsworth, 1971.

2.  For a succint account of it *see* Ananda K. Coomaraswamy: *Introduction to Indian Art*, Theosophical Publishing House, Adyar, Madras, 1923.

3.  For a basal account of it in terms of the state of the economy, *see* Dharma Kumar (ed), *The Cambridge Economic History of India,* Vol. II, *c.* 1757-*c.*1970, Orient Longmans – Cambridge University Press, Delhi/Cambridge 1982, pp 36-241. Or picturesquesly, as 'Chaos lurking beneath the surface of Indian life, replete with tension of our tragic age, in which the old Gods have dissolved and made room for vital energetic figures asserting themselves in violent distortions'. Mulk Raj Anand in his critique of Nandagopal ( *'Nandagopal'*, Kala Yatra, Bangalore, 1985). For an instance: 'The most advanced artists have taken to clothing their Gods in European costume with similar surroundings; thus Shiva is shown sitting in a hall lighted by candles and glass shades , and Krishna drives a Phaeton which is filled by his friends and attendants'. Major Handley, 'Survey of Industrial Arts of Rajputana' in *Journal of Indian Art,* 1886, quoted in Roy.C. Craven, *Indian Art,* Thames & Hudson, London, 1976, 1987.

4.  For a historical account of this movement, *see* Romila Thapar, *A History of India,* Vol.I, Penguin, Harmondsworth, 1961, pp. 186-220 and pp. 304-36. For a more focused account, *see* A.K. Ramanujam, *Speaking of Shiva,* Penguin Classics, Harmondsworth, 1973 in his presentation of Basavanna, a Virasaiva Bhakti saint of the eleventh century.

5.  Romila Thapar, op. cit. and A.L. Basham, *The Wonder that was India,* Sidgwick and Jackson, 1967. Actual exchanges with Christian missionaries are hypothesized (*see* A.K. Ramajujam, op.cit.).

6.  Lord Napier, Governor of Madras in his address to the Native Christian Society, Madras in 1871.

7.  Romila Thapar, op. cit.

8.  In the music of Thiagaraja (1767-1847), Muthuswami Dikshitar (1776-1835), Shyama Shasthry (1762-1827), and Swathi Thirunal (1813-46).

9.  From the very beginning of the movement in the seventh century. The literature that it produced has been described as the 'greatest glory of Tamil literature... which are among the great religious literature of the world' (A.L. Basham, op.cit.).

10.  A phrase of A.C. Danto, the American philosopher.

11.  While important ideas from the music of India had been received into classical Western music through the works of composers like Gustav Holst, Herbert Howells, Alan Hovannes, Olivier Messiaen, and Philip Glass, importations from it have been for the

most part in the area of hardware: the harmonium, violin, clarinet, and most recently the mandolin.

12. That might also account for the failure to evolve a workable economic ideology by the tradition-bound nationalist movement and for the feeble criticism of the economic ideologies of capitalism and socialism from the West. *See,* for a discussion of this question, William Kapp, *Hindu Culture, Economic Development and Economic Planning in India,* Asia Publishing House, 1963. *Also* Gunnar Myrdal, *Asian Drama An Enquiry into the Poverty of Nations* Harmondsworth, Penguin, 1968, especially his notion of the 'Soft state'.

13. Notably those of Mani Nagappa in Madras, Hironmoy Roychoudhury in Bengal, and G.K. Mhatre in Bombay; not to mention the 'Gold Medallists' and those in sculpture shops offering 'Statues and busts ... executed to order in marble, bronze and plaster'. *See* Ratan Parimoo, *Studies in Modern Indian Art,* Konark Publications, New Delhi, 1975.

14. Pilloo Pochkhanawala in *Indian Sculpture Today,* Jehangir Art Gallery Publication, Bombay, 1983.

15. 'We live in a secular and industrial age and we cannot revive the glory of the past era without its mainsprings — religion and princely order' reasoned A.M. Davierwala, *Sculptor's Vocation,* Art Heritage, New Delhi, 1978-9 .

16. Loyalty to material, three dimensional palpability, activization of space through juxtaposition of solids and voids as clarified by Brancusi, Gabo, and Moore (Ratan Parimoo , op.cit.).

17. That had been the point of the progress of painting in the Western tradition from the Impressionists to the Abstract Expressionists. *See* Harold Rosenburg: *The De-definition of Art*, Secker & Warburg, London, 1972. The drastic change in Western epistemology corresponding to the above change in the arts was brought out by Wittgenstein, Heiddegar, and others. For a tightly presented panoramic account, *see* Richard Rorty, *Philosophy and the Mirror of Nature* (Princeton University Press, 1979). For an informal account, *see* William Barret, *The Illusion of Technique* (Anchor Press, Doubleday, New York, 1978).

18. That would seem to be the progress of sculpture in the Western tradition from Rodin, through David Smith to say Martin Puryear.

19. Dhanraj Bhagat in *Indian Sculpture Today,* Jehangir Art Gallery Publication, Bombay, 1983.

20. Alexander Archipenko (1887-1964), Julio Gonzalez (1876-1942), Pablo Picasso (1883-1973), Alexander Calder (1898-1976), and David Smith (1906-65); particularly David Smith whose hieroglyphic iron sculpture is strongly reflected in Bhagat's work and also seminally in the work of Nandagopal of Madras.

21. Kant's formulation is found in his *The Critique of Pure Reason,* trans. Norman Kemp Smith, Macmillan, London, 1933.

22. 'They have in them the seed of a great evolution' said K.C.S. Paniker prophetically, 'which seems to take in its stride the contribution of the East as well as the West, fusing the two in an acceptable whole'. Paniker seems to have sensed it from his earliest work. K.C.S. Paniker (Sunanda), 'Dhanraj Bhagat', *Artrends,* Vol. I, No. I., Madras, Oct.1961.

23. Dhanraj Bhagat in *Lalit Kala Contemporary,* Nos. 12 and 13, New Delhi, April–Sept. 1971.

24.   Richard Rorty, op. cit.

25.   The abandonment came after reading J.Krishnamurthy, who said 'there is no God'. He thereafter returned to lyrical human form in wood.

26.   Principally that of Ramkinker Baij, Prodosh Dasgupta, D.P. Roychoudhury, and Chinthamoni Kar.

27.   Notably that of Auguste Rodin (1840-1917), of humanity that 'is swept by the wildest and most excruciating passions by a movement chosen for its action, tension and violence so that gestures become a language dominated by the cry' (Jean Selz, *Modern Sculpture*, Heineman, London, 1963, p.110).

28.   The premises might well have been 'a search towards a maximization of expression and communication; great passion and vitality; and an infectious love of life and its celebration in a sensuous and dynamic art' (Anita Dube, *Seven Young Sculptors*, Kasauli Art Centre, New Delhi, 1985).

29.   Anita Dube, op. cit.

30.   'Santhal Family', 'Harvester', 'Poets Head'.

31.   According to the critical method formulated by Jacques Derrida. For a summary presentation *see* Christopher Norris, *Derrida*, Fontana, London, 1987.

32.   The Madras School of Art and Crafts was started as a private instiution in 1850 by Colonel Alexander Hunter, a surgeon in the British army. It was taken over by the government in 1859. It was upgraded to the Government College of Art and Crafts, Madras in 1963.

33.   'Emblems, waterpots, wrought-iron gates, ornamental doors and windows, chairs, benches, carved tables and inlaid mirrors.' Josef James, Documented survey of the development of modern art in the region of Tamil Nadu, Lalit Kala Akademi, New Delhi, 1993 (unpublished manuscript).

34.   Those from Bengal included Prodosh Dasgupta, Gopal Ghose, and Sushil Mukherjee. Those from Andhra consisted of some from the Art School at Machilipatnam where Nandalal Bose had taught, associates of that outstanding painter Damarle Rama Rao of Rajamundhry, and K. Madhava Menon from Kerala.

35.   See the biographical sketches of Dhanapal, Nandhan, Nandagopal, and Vidyashankar Sthapathy in this volume.

36.   Consider the paintings of K.Srinivasulu and the early work of Sultan Ali, two of the early emulators of the Bengal style.

37.   Auguste Rodin, Henry Matisse, Henry Moore.

38.   To Matisse's sculpture, for instance.

39.   K.C.S. Paniker quoted in Anjali Sircar, *Dhanapal — Pioneer Sculptor of South India*, South Indian Society of Painters, Madras, undated.

40.   The painters involved are principally K.C.S. Paniker, L. Munuswamy, A.P. Santhanaraj, Reddappa Naidu, Vasudev, V. Viswanathan, Susairaj, and Suryamurthy.

41.   Josef James, 'The New Figuratives', *Lalit Kala Contemporary* No.35, New Delhi, September 1987.

42.   Ibid.

43.   Consider the drawing in the Jaina miniatures which, according to the historian Romila Thapar, might well have an earlier ancestry in the temple murals of Deccan and South India painted from the ninth century onwards. (Romila Thapar, op.cit).

Note also the similarity to the drawing in the murals of the Nayak period in the South, and also to Andhra *Kalamkari* drawing.

44   This was eventually achieved by Paniker in his late 'Words and Symbols' series of paintings.

45.   Rani Nanjappa, 'New look at Creative Handicrafts: The Artist as Craftsman', *Artrends,* Madras, July–Oct. 1966,

46.   Bimal Krishna Matilal, *Perception : An Essay on Classical Indian Theories of Knowledge*, Clarendon Press, Oxford, 1986/Oxford University Press, Delhi, 1990, Ch.2.

47.   Ibid.

48.   Ibid.

49.   *See* 'Tradition and Influence', *Artrends*, Vol. I, No.2, Jan. 1962; 'In Search of the Roots for a Breakthrough', *Artrends* Vol. IV, No. I, Oct. 1964; 'Art and Anonymity', *Artrends* Vol.IV, Nos. 2 & 3, Jan–April 1965; 'The Life Class', *Artrends,* Vol.IV, Nos. 4 & 5, July–Oct. 1965; 'Restraint', *Artrends* Vol. V, Nos. 2 & 3, Jan–April 1966; 'The Indian Element', *Artrends*, Vol. V, No. 4 & Vol.VI, July–Oct. 1966.

50.   Josef James, 'The New Figuratives', *Lalit Kala Contemporary* 35, Sept. 1987; also Josef James, *Sculpture : The Madras Metaphor*, Art Heritage, New Delhi, 1991.

51.   Ajay Kumar, 'Kanai Kunhiraman — The Primitive and the Modern', *Lalit Kala Contemporary*, 35, Sept. 1987.

52.   This is strongly indicated in Philip Rawson, 'Methods in Indian Sculpture', in *Oriental Art and Asian Review*, Vol. I, No.3, Dec.1964.

53.   Consider the line of work from Archipenko and Gonzalez through David Smith and Anthony Caro, down to Richard Serra.

54.   Consider the Ayyanar horses in terracotta, guardian deities in rural Tamil Nadu, which are believed to fly around the village when it is dark (N.R. Bhuvarahan, 'Terracottas of Tamil Nadu', *Nunkalai,* Vol. I, No.I, Madras, 1986-7).

55.   Michael Brenson on Richard Deacon, 'Sculpture Breaks the Bond of Minimalism', *New York Times,* 23 Nov. 1986.

56.   Tom Lubbok about Tony Cragg in *Independent on Sunday*, 2 Aug. 1992.

57.   John Russel on Donald Lipski, 'Turning the Plain into Fantasy', *New York Times*, 15 March 1982.

58.   John Russel, op.cit.

59.   'The static, portable indoor art object (a rather nice materialistic way to describe a painting or sculpture) can do not more than carry a decorative load that becomes increasingly uninteresting'. Sculptor Robert Morris as quoted in Harold Rosenberg, *The De-definition of Art-Action Art to Pop to Earthworks,* Secker & Warburg, London, 1972, p.1. *See also* A.C. Danto, *The Philosophical Dis-enfranchisement of Art*, Columbia University Press, New York, 1986, p.118.

60.   The effect is suggestive of the Nominalist approach to a work of art as argued by Nelson Goodman, *Language of Art—An Approach to the theory of Symbols*, Hackett Publishing Company Inc., Indianapolis, 1968. For a critique of it, *See Max Black, Caveats and Critiques*, Cornell University Press, 1975.

61.   *See,* for a detailed explication, Bimal Krishna Matilal, *Logic, Language and Reality — Indian Philosophy and Contemporary Issues*, Motilal Banarasidas, Delhi, 1985–1990, pp.164-202.

62.   A definition taken to mean amenability to perception or *yogyata* (Bimal Krishna Matilal, ibid).

63.   A.R. Lacey, *Dictionary of Philosophy,* Routlege & Kegan Paul, London, 1976.

64.   Ibid.

65.   Patterning as the   prime principle in picture-making was established by K.C.S. Paniker in his 'Words and Symbols' paintings. The notion, however, is not in any way novel. The foundational importance of this device to aesthetic experience has been pointed out earlier: 'Art rests on the fact' says Richard Wolhiem, 'that deep feelings pattern themselves in a coherent way all over life and behaviour' (*see* his *Art and its Objects,* Harper & Row, New York, 1968, pp.112). Its potential for a 'deeper, more mystical and symbolic significance than pictorial art can itself claim' has been noted. It 'not only prepares the soul for the reception of these imaginative works, but develops into that sense of form which is the basis of creative, no less than critical achievement'. E.H. Gombrich, *The Sense of Order—Study in the Psychology of Decorative Art,* Phaidon, Oxford, 1979, pp. 58-9. The pattern as intrinsic control of the open form can be noticed in Japanese Zen drawing. For an illustration, *see* Paul Reps, *Zen Flesh and Bones,* Penguin, Harmondsworth, 1971. Its connection with craft in that culture has been very sensitively analysed; *see also* Soetsu Yanagi, *The Unknown Craftsman— A Japanese Insight into Beauty,* Kodansha International, California, 1972. It connects with the use of script and texts as patterns. *Also see* E.H. Gombrich, op.cit., p.146. Such usages are characteristic of the Chinese and Islamic traditions (H.W. Janson, *History of Art,* Prentice-Hall/ Harry Abrams, New York, 1962). The great importance given to this device in the Jewish tradition proved to be of deep interest to Jacques Derrida in his study of 'Textual' traditions. *See* Christopher Norris, op.cit.,pp.228-38. Paniker discovered it to be an extremely supple graphic which can elocute  without picturing or showing; an ideal patterning device.

66.   It was actually dismissed on one occasion as 'handicraft'. *See* 'Richard Hunt and Prodosh Das Gupta — A Conversation', *Lalit Kala Contemporary,* 26 Sept. 1978.

67.   G. Siromoney, R. Siromoney, and Kamala Kirthivasan, 'Abstract Family of Matrices and Picture Languages', *Computer Graphics and Image Processing,* Vol.1, 1972 and by the same authors, 'Array Languages and Kolam ', op.cit.,1974.

68.   See 17 above.

69.   Peter Fuller, 'The Failure of American Painting', *Village Voice,* 27 Aug.1979.

70.   A.C.Danto, op. cit., p.118.

71.   Peter Fuller, op. cit.

72.   Phyllis Granoff, 'S. Nandagopal — A modern visionary in an ancient tradition', *Art International,* Lugano, Switzerland, March/April 1980.

73.   Mulk Raj Anand, op. cit.

74.   Ibid.

75.   Jana Deva in Anubhava Mithra. *See* Dilip Chitre's introduction to his translation of Tukaram in *Tukaram, Says Tuka,* Penguin Classics, Harmondsworth, 1991.

76.   'O, Wealth, my treasure, lustre fair of heavenly hosts/ Of lustre glory that excels, embodied one, my kin/ My flesh, yea heart within my flesh, image within my heart/ My all bestowing tree, my eye, pupil, my eye within/ Picture seen in that pupil/ Lord of Aduthurai cool/ Immortals king, keep far from me the strong pain of fruits of sin.' An unworthy translation from Tamil of a hymn of Tirunavukkarasu Swamy, a Bhakti

saint of circa the seventh century *in* F. Kingsbury and G.E. Philips, *Hymns of the Tamil Saivite Saints* (Oxford University.Press, 1921).

77.  The transition from an idealistic 'command' phase to an amoral 'demand' phase of the political economy of India is expounded in Lloyd I. Rudolph and Susan Hoeber Rudolph, *In pursuit of Lakshmi — The Political Economy of the Indian State,* Orient Longman, Bombay, 1987.

78.  K.G. Subramanyan, *The Living Tradition — Perspectives on Modern Indian Art,* Seagull Books, Calcutta, 1987.

79.  For a Critique arising out of such a situation, *see* Geeta Kapur, 'Partisan views about the Human Figure', *Place for People,* Jehangir Art Gallery, Bombay and Rabindra Bhavan, New Delhi, 1981.

80.  Anita Dube, op.cit.

81.  *See*, for instance, *Four Sculptors — Fourteen Sculptures,* Trivandrum Fine Arts College, 1992.

82.  Meera Mukherjee's 'Ritual Dance'.

83.  See biographical sketch in this volume.

# DHANAPAL

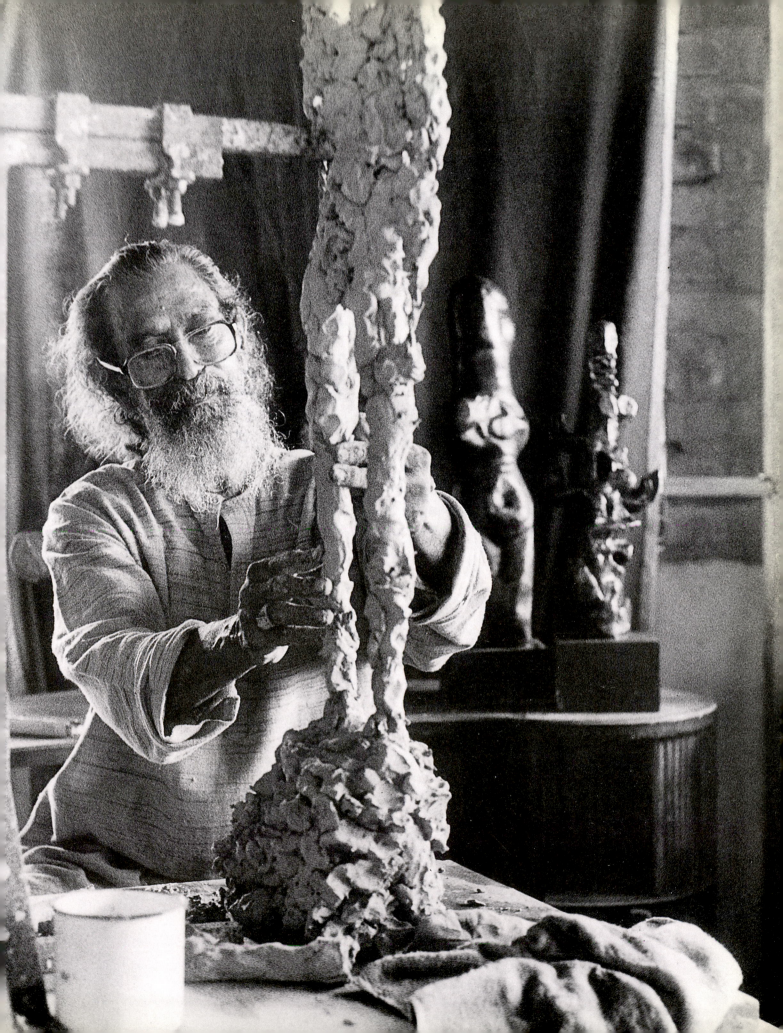

# S. Dhanapal

The last monuments of the Indian tradition of sculpture in the eighteenth century were in South India. This ancient heritage was a part of the living tradition of the people until quite recent times. The intense and complex cultural patterns of Shaivite society were so variegated that although the European impact was felt earlier in the South than in the rest of the country, the modern impulses from the West were largely ignored except by the princes, the nobility, and some sections of the intellegentsia. Only the youngest generation of artists sought to raise fundamental questions and come to terms with the problems of contemporary vision with any degree of earnestness. One such artist was the up-and-coming sculptor, S. Dhanapal.

Dhanapal was born in the city of Madras on 3 March 1919. He grew up in an ancient settlement around the famous Kapaleeswarar temple at Mylapore in Madras. The great temple with its architecture, sculpture, festivals, music, lights, and dancing provided the atmosphere in which he spent his childhood. His early interest in things of beauty and their workmanship must have had a great deal to do with the culturally rich environment of his boyhood days. He would stay back watching craftsmen at work, especially, he remembers, an old old man near the temple tank making wood carvings for the temple chariot. He remembers his fascination for the small bronze figures his mother worshipped routinely at home. At school he sketched animals and flowers and spent the rest of his time outdoors copying Chola and Pallava bronzes.

His talent was noticed early by many well-wishers, especially his art teacher at school. He caught the attention of a traditonal master in the locality, Govindarajulu Naicker, who prepared him for the art school. Dhanapal passed the entrance examination of the Madras School of Arts and Crafts, thanks to the coaching Govindarajulu Naicker had imparted, and soon found himself under the tutelage of the distinguished sculptor Devi Prasad Roy Choudhury, then the Principal of that institution.

The formative influences on Dhanapal, as on his contemporaries at the Madras School, were the Bengal movement and the Impressionist movement abroad. Both these he imbibed from Roy Choudhury, his teacher. Of them he was more inclined towards the Bengal School because it seemed closer to his

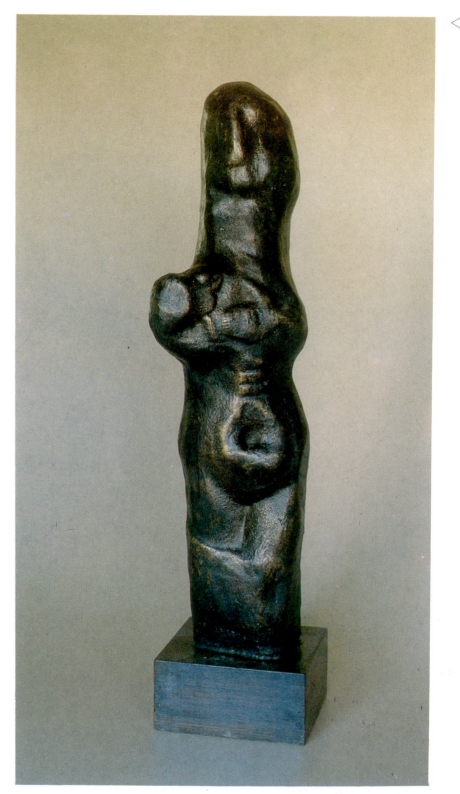

◁ 'Mother & Child'
Bronze
1950

own thinking and feeling. He was deeply impressed by Nandalal Bose's drawing but his own experience of modernity prompted him to look beyond that powerful influence. Gaganendranath Tagore's paintings, employing a modern use of line and space, fascinated him and he experimented with it in many of his early paintings. He cites especially 'Man with Umbrella', a water-colour in transparent greyish-green in the Japanese style and 'Bull', a forceful depiction in sculptural form influenced by the Pallava style. These paintings of his younger days were clearly a combination of Nandalal Bose, Gaganendranath Tagore, and Rabindranath Tagore, together with some influence of the Chinese style. Some of these paintings found their way into collections of the royal families in the South.

By 1940, when Dhanapal completed his course at the Madras School, he had developed a considerable reputation for his delicate drawings in brush or pencil of classical themes such as 'Festive Mood'. His line drawings were beautifully lyrical and one could discern in them the influence of Chola murals of the ancient Tamil country.Dhanapal actually started out as a painter. Roy Choudhury, his mentor started out as a painter and later turned to sculpture, and was then preoccupied with portrait sculpture. Noticing Dhanapal's aptitude for carving and moulding, he took him under his wing and trained him to be a sculptor.

The academic routine at the Madras school, of copying models, left him little time or opportunity to study materials and to think freely about subjects for sculpture. He decided therefore to explore these areas himself, bearing in mind the stalwarts of the Bengal school and the spirit of free expression found in the work of the Impressionists abroad. By that time, he had, over a period of twenty odd years, drawn from the rich folk tradition of the region and discreetly from classical bronzes to evolve a personal idiom in sculpture which combined historicity with contemporaneity. The freshness and promise in his work was unmistakable. At the national level it belonged to the class of historic work which established the period as a definitive one in the evolution of contemporary Indian art. He was the first artist to turn traditional elements into progressive ideas in contemporary Indian sculpture.

In 1955, he attracted attention with a piece entitled 'Namaz', using plaster of Paris as his medium. This sculptural figure is distinguished by the narrowing stance of a bent man with a lean face. It has a certain lyrical sweep, almost as though a painter's brush has been at work. The static stump of the legs, placed squarely on the pedestal, offers a contrast to the lean and  graceful near-abstract figure.

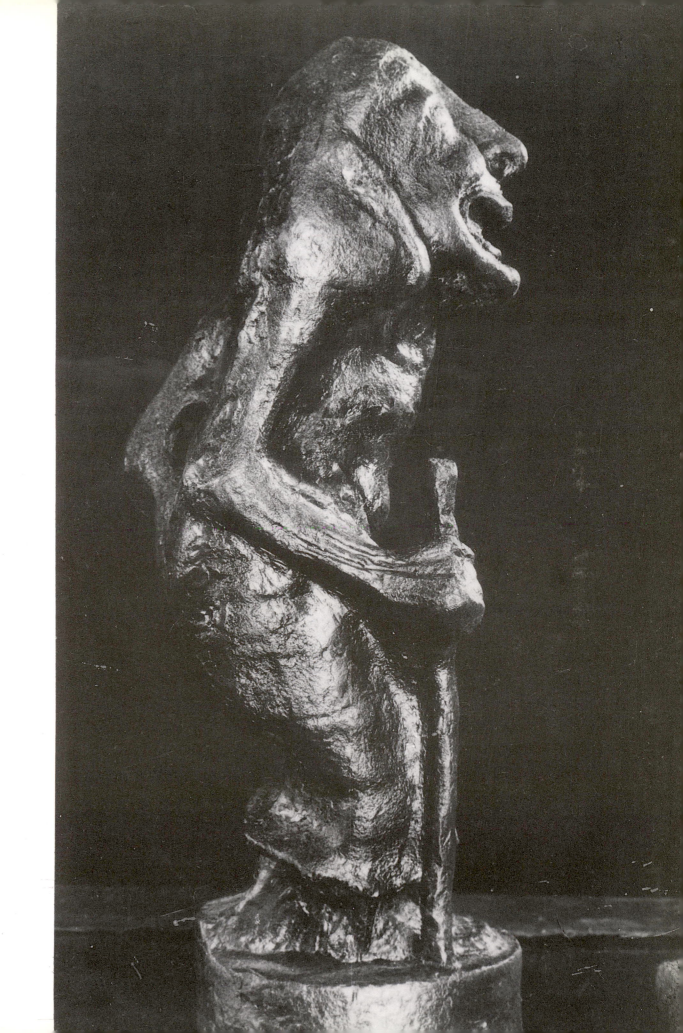

'Avvaiyar' ▷
Bronze
1960

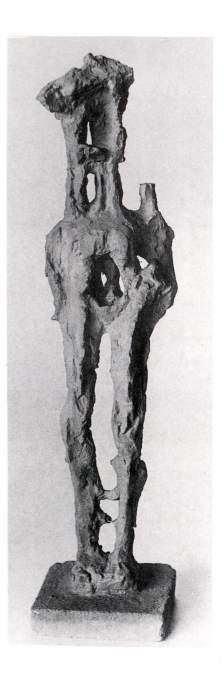

◁  'Torso
    Cement
    1975

▷  'Cow & Calf'
    Wood
    1962

By 1957, Roy Choudhury had re-
tired and K.C.S. Paniker, one of the
foremost Indian painters, had taken
his place as Principal of the Madras
School of Arts and Crafts, now el-
evated to Government College of
Art and Crafts. Dhanapal had by
then joined as an instructor and was
working in terracotta. Writing about
his contemporary in 1960, Paniker
noted:

'Those who noticed his great aptitude to
continue the grand manner of the Pallava
and Chola draughtsmen of the South in his
competent and delicate drawings cannot be
surprised at his blossoming into a sculptor
of distinct merit. Dhanapal's compositions
in sculpture in the Indian manner are per-
haps the things which will fully stand for
him in the years to come. They have those
peculiarly vital and genuine sculptural
qualities which should distinguish them as
the work of a man who has imbibed not
only the best traditions of his native country
but also interesting aspects of contemporary
world sculpture.

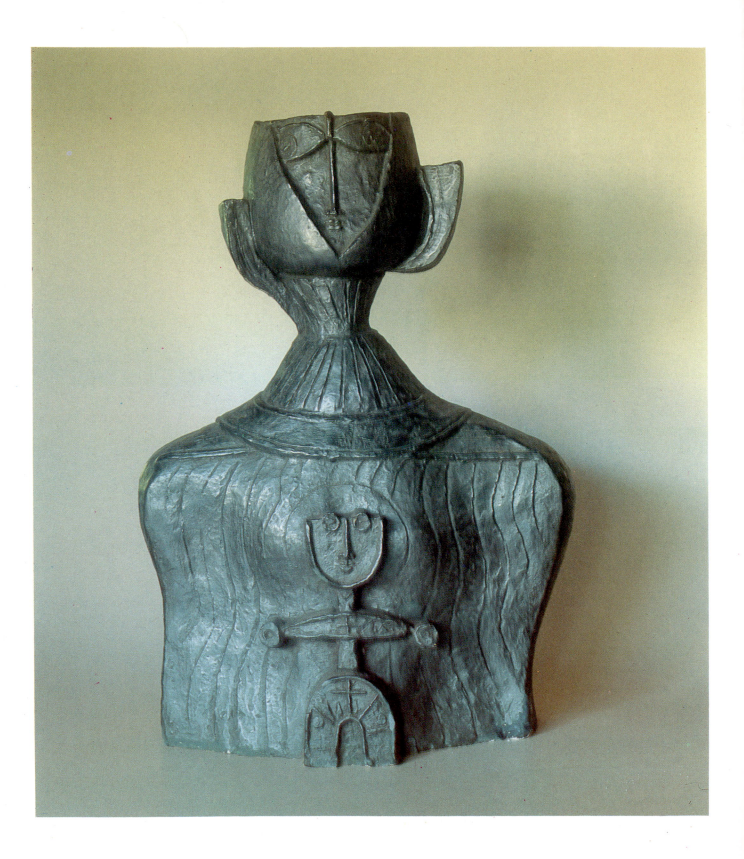

◁ 'Mary & Christ'
Bronze
1987
Collection : South Zone Cultutal Centre

The freshness of Dhanapal's sculpture, its appeal, and its strength lie in its remarkably free, humanistic rendition. Whether in terracotta, bronze, or cement, the traditional form or image he works is moved by deep humanistic feeling. The humanistic urge, it may be pointed out, was common to the noteworthy work of Indian artists of this period. It constituted , so to say, the poetic burden and joy of the whole modernistic approach. In that larger movement Dhanapal's distinction lies in his attempt at linking indigenous sources, folk and canonical, through a fludity of expression and rhythmic articulation with the contemporary surge or deep humanistic feeling.

His 'Mother and Child' in terracotta is an experiment in the extension of the traditional folk style into a fundamental structure. The realistic physiognomy of both the woman and her son carry an element of distortion but retain the naturalist frontality. The mass of the composition of the squat body goes back to the premises departed from in 'Namaz'.

In the 'Head of Christ' in terracotta, the sculpture achieves a Daumier-like caricature in a visage imbued with the dominant mood of pain. The enlarged eyeballs, the broken nose, the hollow cheeks, and the open mouth above the enlarged chin, all are used to heighten the agony. The hollows break the impact of the mass and achieve a moving sculpture which was to be the hallmark of his style as a sculptor.

'The Head' in terracotta is another caricature which strikingly sublimates the dominant mood of suffering. The linear flow of the arched eyebrows and the nose continues the long line of the neck with a characteristic neo-realism. The exaggeration of the full rounded cheeks and the pinched mouth as well as the typical raised eyes, show the sculptor's obsession with the deeper nuances of suffering. The influence of the old terracotta technique is obvious, but there has been a genuine departure in the confrontation of sorrow by the sculptor.

Dhanapal's sculptures were exhibited at an All-India exhibition in 1958, at Delhi. During a later exhibition in 1960, his sculpture 'Christ bearing the Cross' in bronze created a deep impact. The sculpture carries the expressionist elements so far present into a structure where the suffering of man becomes incarnate. The incisions on the body exaggerate clearly and unmistakably the spirit of pain, while the twist of the head on the vertical body dramatizes the ancient postulates of the Christian experience. This sculpture, which was exhibited at the Commonwealth Countries Exhibition in London in 1962 received the National Award of the Lalit Kala Akademi in the same year.

If the previous studies had already adopted abstraction, the realistic

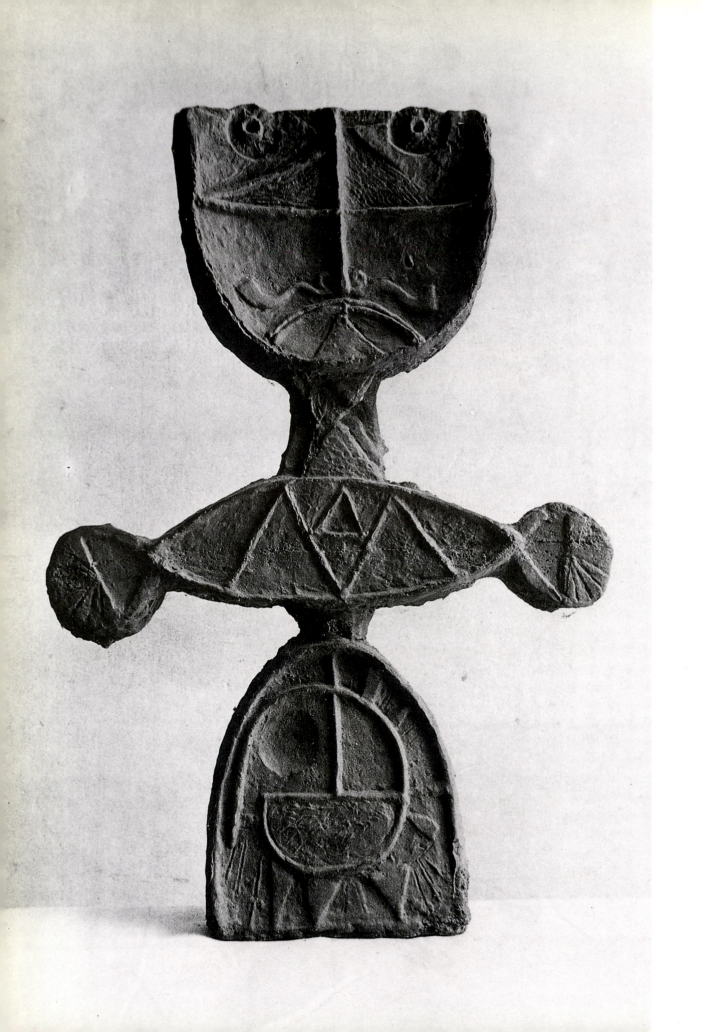

◁ 'Village Deity'
Bronze
1987

▽ 'Composition'
Bronze
1975

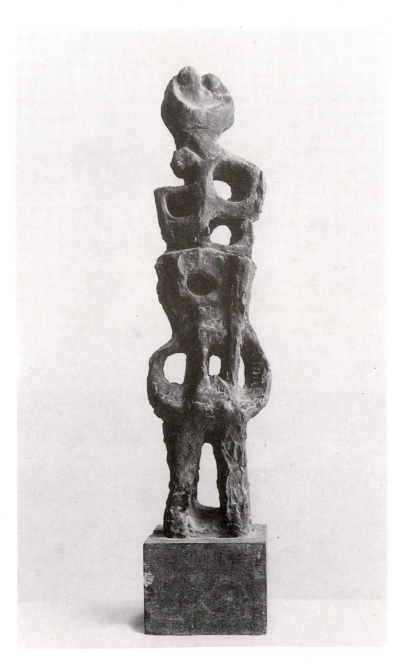

▷ 'Shakthi'
Bronze
1974

features of 'Avvai' go back to realism with a human sympathy which is not absolutely self-contained, but borrows a good deal of literary metaphor. The form is powerful, but does not depart from its axis.

In 'Mother and Child', the technique with bronze is used with tenderness; but there is no substantial gain, except in virtuosity. Certainly there is a tremendous progress discernible  from the terracotta, 'Mother and Child' he had done earlier.'Standing Figure' in bronze is an experiment in a dramatic structure along the lines of Dhanapal's 'Christ bearing the Cross'. The problems here were more intricate because the sculptor tried to achieve movement almost as in a dance, in a material which does not lend itself easily to the nuances of peripheral waves. Thus the torso and the interlocked circular arms achieve a certain poise as though the figure is frozen in the act of dancing; the static lower portion weights the structure, contradicting the aspirations of the upper part.

In the 'Horse' in concrete, Dhanapal achieves the climax of his technique with rough texture. The heightened drama of the thrust of the head carries the whole massive lower structure almost into flight. The experiment with the rough modelling and the base contains all the elements which have so far been evidenced in other work.

With 'Three Figures', in bronze there is a mature attempt at composition in broken space. This monumental sculpture embodies a grace and finish above the rough texture, which shows Dhanapal to be possessed of a dominantly metaphysical temperament, aware of the deeper rhythms of human life.

Considered over the years,Dhanapal's expression appears riddled with powerful thrusts, pulls, contractions, throbbing, and painful incisions. It bespeaks a state in which the elaborate divinity of the Pallava muralists and the mythically precise figurations in the classical bronzes of the region are being forced up and tested by his forceful humanistic feeling. It could not have been otherwise for an artist like Dhanapal who, nurtured in both tradition and modernity, is troubled by a human core which the contemporary world awakened within it. The one thrusts into the other incessantly in his work, sometimes with very dramatic efffect, as for instance in his bronze 'Avvai'. The remarkable thing is that even in such extreme instances, where his work looks dangerously tilted, it never ends up one-sided. The odds appear even at the end between the rich cultural factor and the existential human factor. This has been a rare achievement and the one which made him a successful teacher of sculpture, which he continued to be till his retirement in 1977. His

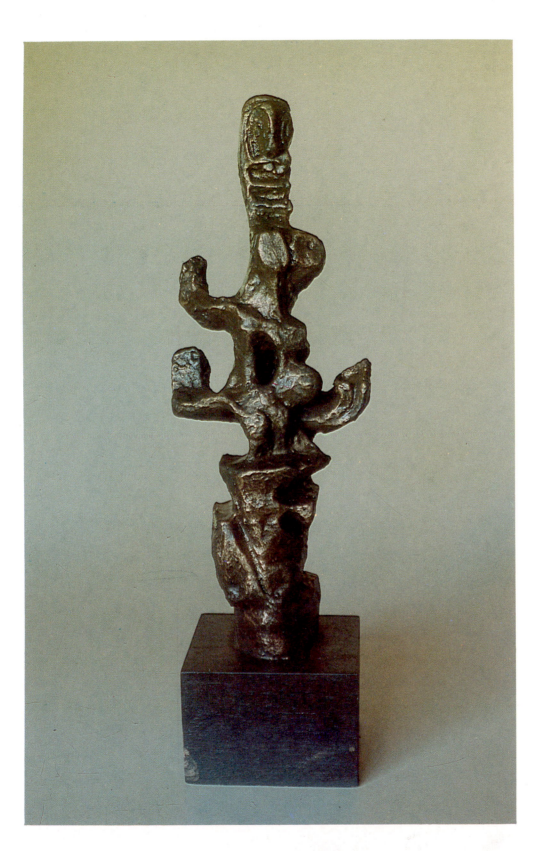

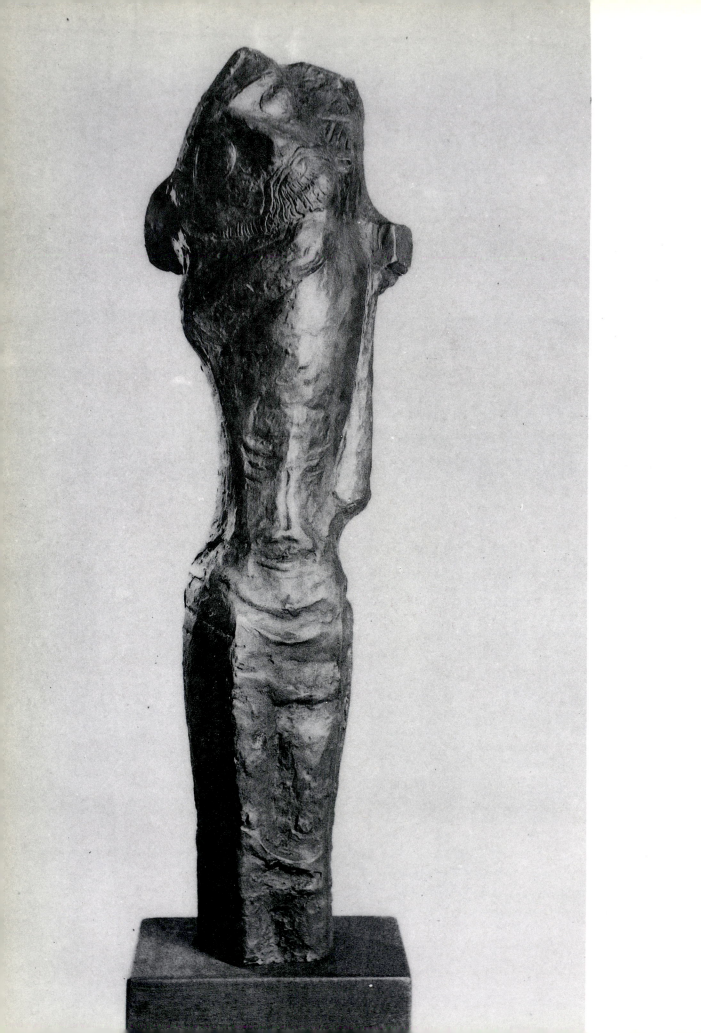

◁  'Christ'
Bronze
1961

▷  'Mother and Child'
Terracotta
1957

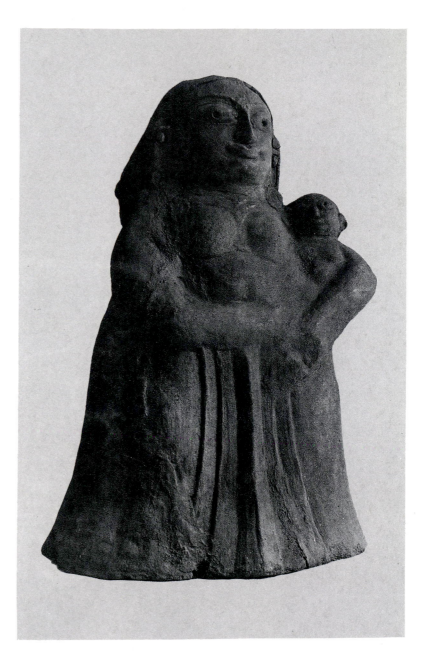

students found in his work a fair statement of the issue which left them free
to take it in any direction their inspiration willed. He opened up exceptional
possibilities in his work, encouraging them to discover their own genius and
forge further ahead.

Mulk Raj Anand

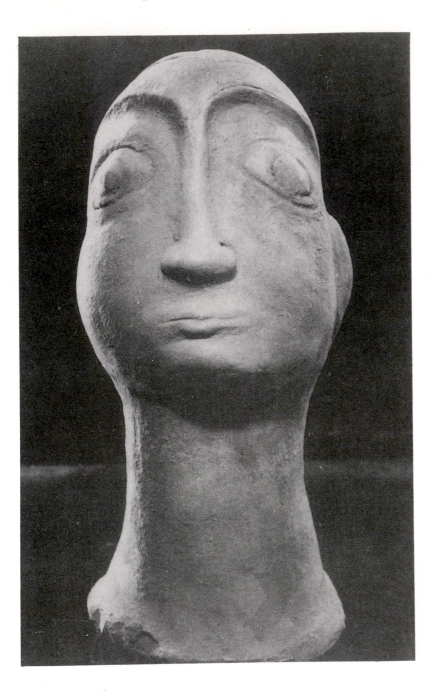

'Head'
Terracotta
1958

DHANAPAL

1919      born, Madras

1935-40   trains in painting at the Government College of Arts and Crafts, Madras

1941      joins as a staff member in the Faculty of Fine Arts, Government College of Art and
          Crafts, Madras; is involved in various activities in the field of arts and takes keen
          interest in the development of art in the State

1957    *takes charge of the Sculpture Department; does a number of sculptures in various media*

1959    *International Art Exhibition, West Germany.*

1962    *Commonwealth Art Exhibition, London; National Award at the National Exhibition of Art, New Delhi*

1966    *establishes Cholamandal Artists' Village along with K.C.S. Paniker*

1971    *travels in Yugoslavia and other European countries and visits important museums and art galleries*

1972    *appointed Principal, Government College of Art and Crafts, Madras. 25 Years of Indian Art travelling exhibition organized by the Lalit Kala Akademi.*

1977    *retires as Principal, Government College of Art and Crafts, Madras*

1980    *Silver Jubilee Exhibition of Sculpture, held by the Lalit Kala Akademi in different centres in India; Fellowship conferred by the Tamil Nadu Lalit Kala Akademi, Madras. Awarded a Two year fellowship by the Government of India, Department of Culture, New Delhi in recognition of his contribution in the field of Fine Arts.*

1982    *Fellowship conferred by the Lalit Kala Akademi, New Delhi*

1991    *'The Madras Metaphor' exhibition organized by Ebrahim Alkazi at Art Heritage gallery, New Delhi*

# JANAKIRAM

# P.V. Janakiram

P.V. Janakiram, sculptor from the South, appeared on the uneven landscape of sculptural art in the Sixties like a winged god. He belongs to the second wave of the Indian Renaissance that seemed to grasp in one breathless sweep all the new ideas that were coming in from the West, even as it re-awakened and sought out the forgotten streams of Indian artistic expression. Janakiram's figures of beaten metal–copper sheets that were hammered, welded with folded bits of copper and scribbles of thin copper wire, like bundles of raw energy, appeared to be poised for flight. His technique of pushing out his figures from the back of crudely cut metal and marking it out with a ridge all around succeeds remarkably in recalling the various elemental shapes that have recurred both in Indian art and architecture. His 'Kings', Madonna figures clutching a child, his 'Christs' with their arms stretched out in a gesture that embraces all humanity, cut through the dogma of modernism that was fashionable at the time, and re-centred the artistic vision within the framework of human experience. It is not for nothing that the work of that period is described as iconic. He celebrates the human condition. His works are filled with the life force or *prana* that Stella Kramrisch, the noted American critic, has observed to be the special characteristic of authentic Indian art or, as Milaṇ Kundera might say, they are filled with 'the incredible lightness of being'.

If there is a tendency to speak of Janakiram in the past tense, it is not because he has stopped working. Janakiram still works for at least two hours a day, either in the early mornings or evenings, depending on the weather. At the age of sixty-two, somewhat debilitated by a heart condition, he sits in the house where he was born, in one of the older suburbs of Madras, in the shadow of the great Buckingham and Carnatic Mills (Binny's), and talks about the glory days of his prime when visiting Hollywood stars would buy his work hot from the strokes of his imagination.

It is an old-fashioned house, with a narrow entrance onto the street, built around a series of inner courtyards, linked by narrow staircases that lead to a room at the top which serves both as a living room and bedroom. His small

▽ 'Head'
Welded Copper Sheet
1990
Collection : Mr. & Mrs. Sridharan

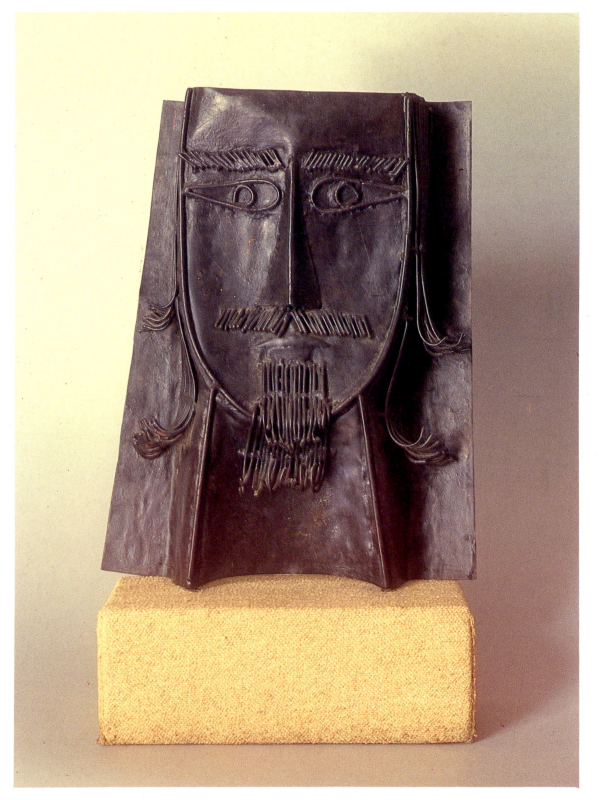

▷ 'Devotee'
Oxidized Welded Copper
1965

workshop, which he calls his studio, is at the entrance to the room. Across the terrace there is another small room where he does his welding.

He is a medium-sized man with a smooth mahogany skin that is all the more noticeable because he appears bare-bodied due to the heat, with a white dhoti, or *veshti* as it is known in the South, tied around his waist. He has large melancholy eyes with heavy lids, his ears have been pierced, and what is left of his hair hangs down in wisps. His most striking feature is however his frank smile. The mouth curves up to reveal a strong set of ivory-coloured teeth and with it a luxuriant moustache curling upwards and outwards. Curiously, these details appear in some of his earlier pieces, when his figures would appear in all their naked vulnerability with rudiments of clothing around them, or his heads would show the same heavy-lidded eyes, strong nose, and small mouth, with the wire curving round in tendrils, forming a moustache, beard, or a head of hair.

He says that he finds it difficult to articulate his thoughts in English, but when he sits down to work he says 'My mind is very clear, I know exactly what I want to do. The moment I am in front of the blank sheet with the chalk in my hand, that is a moment of great happiness for me.' He darts about the room pointing to the prizes and awards that he has won in different parts of the world. There are posters acclaiming his contribution in the triennales that were held at Sao Paolo, Budapest, and such other places, and in countries newly created, or baptized by the socialistic ideology of the time, celebrating their new artistic freedom. 'Look', he says, 'myself as Krishna'. The portrait is of a young Janakiram posing in a studio photograph as the child Krishna. Next to it in a poster is a picture of his sculpture of 'Krishna', an award-winning work. The resemblance is indeed striking.

There was nothing in Janakiram's background that would suggest an artistic career except, of course, the normal childhood fondness for drawing. Sometimes when he wants to shock people he tells them that his father was a butcher and that he himself worked in a slaughterhouse. The truth is this: His father, a very wealthy man in his community of Yadavas, owned a slaughterhouse. His business was in skins and hides. This made it possible for the young Janakiram to join the prestigious Government College of Art and Crafts, Madras, which was seen as a right place for the training of a somewhat impressionable and sensitive young man. That he was emotional, there is no doubt. He describes how, when he went into a temple, he would fall into a trance when the crescendo of music and chanting of 'Muruga! Muruga!' rent the air. Often he would faint and have to be carried out. He got his

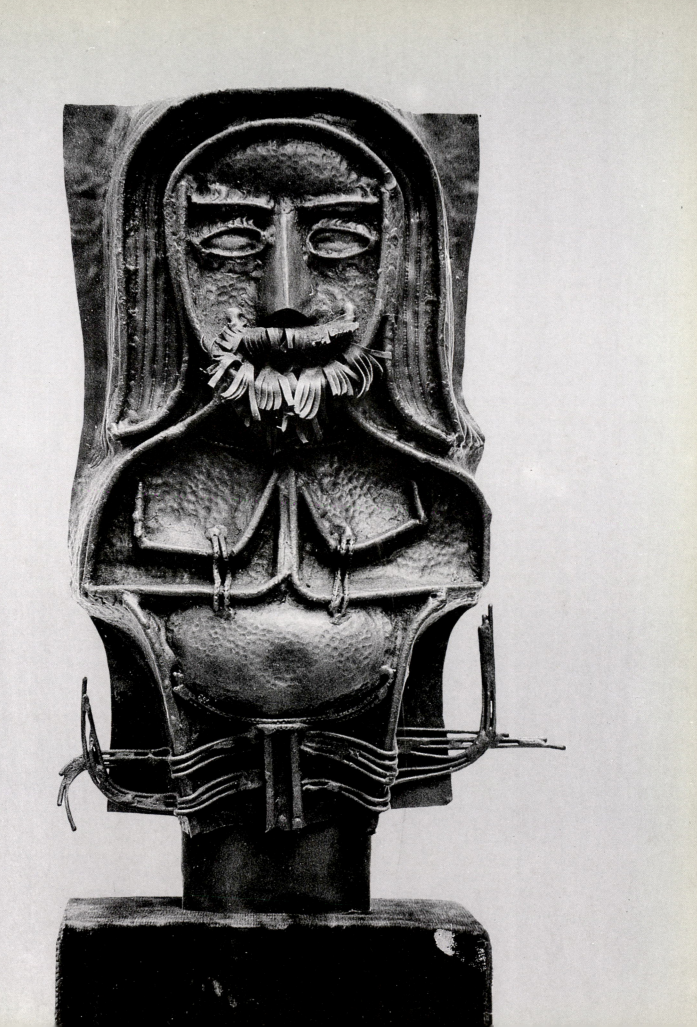

▽   'Shakti'
    Oxidized Copper
    1970

▷   'Owl'
    Welded Copper
    1967

▽  'Ganesha'
Welded  Copper Sheet
1987
Collection : Mr.  & Mrs. Sridharan

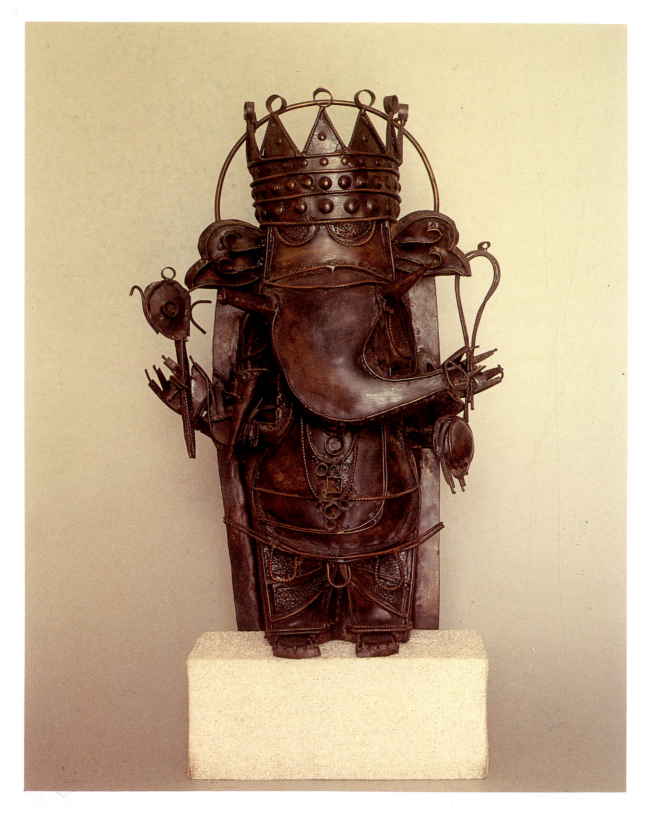

degree in painting in 1953, sculpture in 1963, and commercial art in 1964. Throughout this period it was his daily routine to go over and supervise the work at the slaughterhouse, which was not far from the house. Unlike the young Michaelangelo, who taught himself anatomy by examining cadavers, Janakiram had no thought of learning from his slaughterhouse experience. 'If I did that, I would not be working as an artist now', he says.

Janakiram was fortunate in having the benefit of an artistic training, which though decried subsequently as being based on a Western tradition that tended to produce a staid academic style, did in fact give him a rigorous discipline in the basics of art. With its equal emphasis on the craft element, the outlook at the Government College of Art and Crafts, in the '50s and '60s was what one would expect to find at a polytechnic for the arts. But it had been particularly fortunate in having a number of inspired teachers as Principals, like E.B. Havell and D.P. Roy Choudhury earlier. In the post-Independence period, K.C.S. Paniker was the outstanding personality.

In the spirited dawn of intellectual and artistic ferment which in the South was accompanied by parallel developments in the fields of music, dance, drama, and cinema, K.C.S. Paniker stands out, both as a rebel and as a visionary. It is not for nothing that Janakiram says, 'I owe everything to Paniker. He picked up four of us, Kunhiraman, Vidyashankar Sthapathy, Anila Jacob, and me. He was the force that drove us, who gave us the courage to discover ourselves.' Paniker, teacher, Principal, artist, was that rare creature, an original thinker, whose greatest gift was in discovering, or leading others to discover their own artistic potential. Tantric art, tribal art, folk art, the oral art tradition as recorded in manuscripts of the Ramayana and Mahabharata, the secular art of the Tanjore paintings, were all taken up in turn in his restless exploration. In the South, which was very much an isolated island of activity in comparison with the rest of the country, Paniker, like Prospero on his enchanted island, was able to release the creative energies of all those who came under his spell. Janakiram was one of them.

At the same time there were sculptors like Dhanraj Bhagat in Delhi (via Lahore), Prodosh Das Gupta in Calcutta (he had also studied at Madras), and Ramkinker Baij at Shantiniketan, who were extending the frontiers of Indian sculptural expression. They were conscious of the Western sculptors of the time like Arp, Brancusi, Marini, and Henry Moore, and beginning to discover in the process, some of their own strengths: namely, a more lyrical approach that centred on a rediscovery of the human form, or the 'human condition', as the buzz-word of the time would have it.

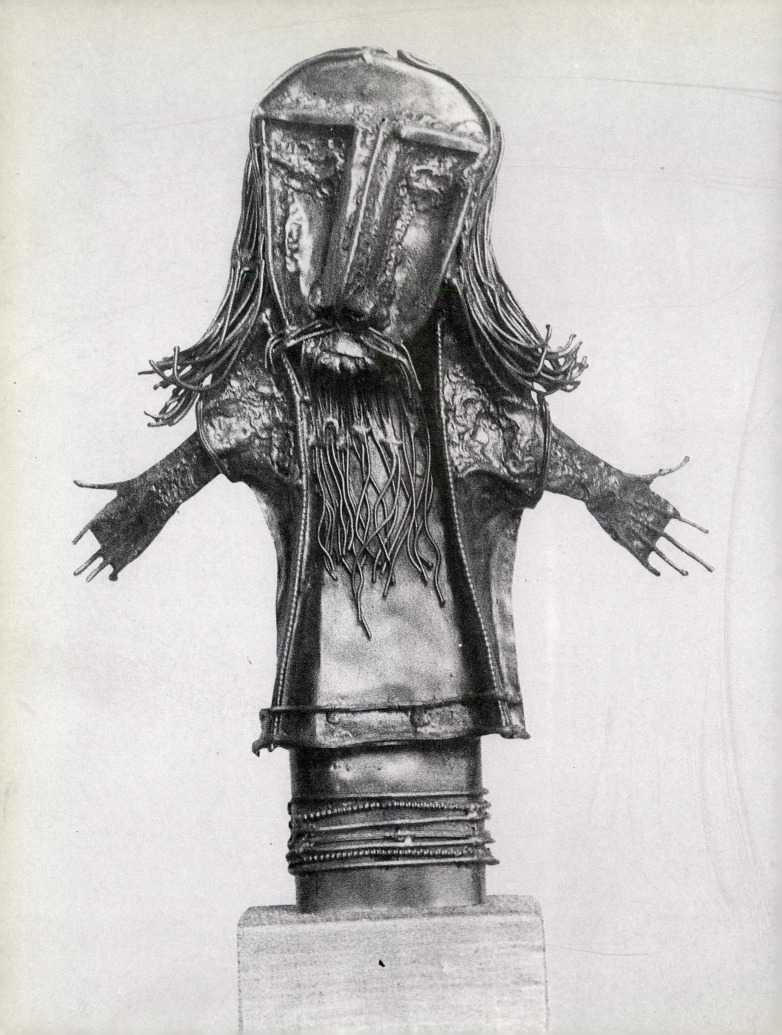

◁ 'Christ'
Oxidized Copper
1966

▷ 'Christ'
Welded Copper
1971

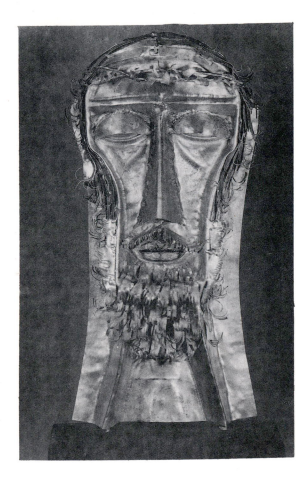

It was against this background that Janakiram found a medium, beaten metal plate or copper sheet, which he was able to make his own. He recalls seeing the temple *Kavacha*s of beaten silver, and the body and face masks, that adorned the deities. He began to adapt the technique known as repoussé work, that consisted of hammering concave surfaces into the metal to serve his style. His early compositions, such as the 'Two Figures', reflect some elements of Dhanraj Bhagat's work: the use of solids and hollows, for instance, and the massing of oval shapes in an abstract manner, even when creating figures. The most striking feature of course is the face-to-face aspect of the work. It has been termed frontal sculpture, or two-dimensional sculpture. Another descriptive term might be pictorial sculpture, though again this tends to be reductionist. On the well-known carved friezes that adorn the

doorways at Sanchi the figures emerge from their stone background, suggesting three-dimensionality, while remaining a part of the whole composition, integrating architecture, sculpture, and painting into one composite expression. Janakiram's early pieces reflect this.

Janakiram's early compositions are highly suggestive of natural forms, 'Yakshis', or tree spirits, with rough, bark-like textures that have been smoothened down to produce a fluid line. In these images, the edges outlining his figures have been raised, like folds of cloth. Even in the 1967 image of 'King: Two' there is a feeling of dynamic growth, very much of the earth, the hands like short branches, and bunched wires that suggest the martial and king-like features, reminiscent of twigs. The 1966 figure of a woman entitled 'The Woman', which was exhibited at Rabindra Bhavan and won a prize that year, is stark and almost pupa-like, as if emerging from the background, and in it one may see the sheet metal in rough, jagged outline. The details are minimal, the face rounded like one of Jamini Roy's women, the heavy-lidded eyes forming a pattern with the swell of the breasts, the fold of the cloth swaddling the pregnant form like the clinging, transparent sheaths of a growing bud.

In the 1965 figure of the 'Madonna and Child' one may see the stylized, elongated elements, that are also a feature of his later work, such as the 'Flute Player' of 1972. 'The Madonna and Child' is gravely beautiful. The figure is lightly etched within a double-ribbed line of repoussé work, the background of sheet metal suggesting both her veil as well as the background that will give the figure all the importance of a memorial stone. The smaller oval of the face is contained in the ovoid shape of the figure, both of the Mother and the Child. While the horizontal bands of decoration define the mood of Byzantine richness, what gives the piece its air of perfect realization is the placement of the hands of the Mother, a little above the mid-point, clasping the child and closing the circuit as it were, to the third oval shape within the main figure. By way of contrast, the 'Flute Player' of 1972 has all these elements, but in an exaggerated form.

In between, there was the phase of Janakiram's 'Owls' and 'Horses'. They were free-standing sculptures composed of repeated strips of material all welded together in a tight bundle of energy, with colour added by means of enamelled pieces. Here too one senses a tenuousness in comparison with the earlier works, where the colour infuses the composition with an added dimension, and those like the 'Owl', done in 1973, which appear curiously stilted. That did not prove to be the end of the road for him. He suddenly

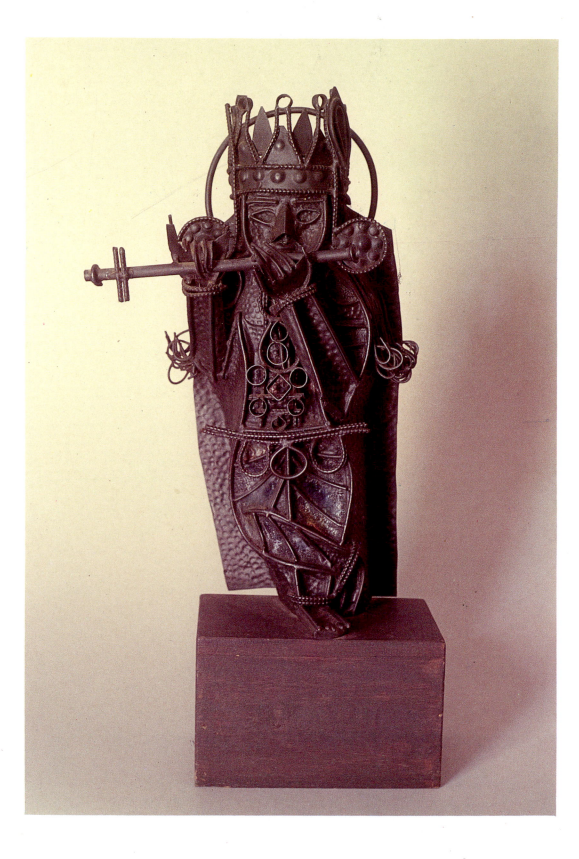

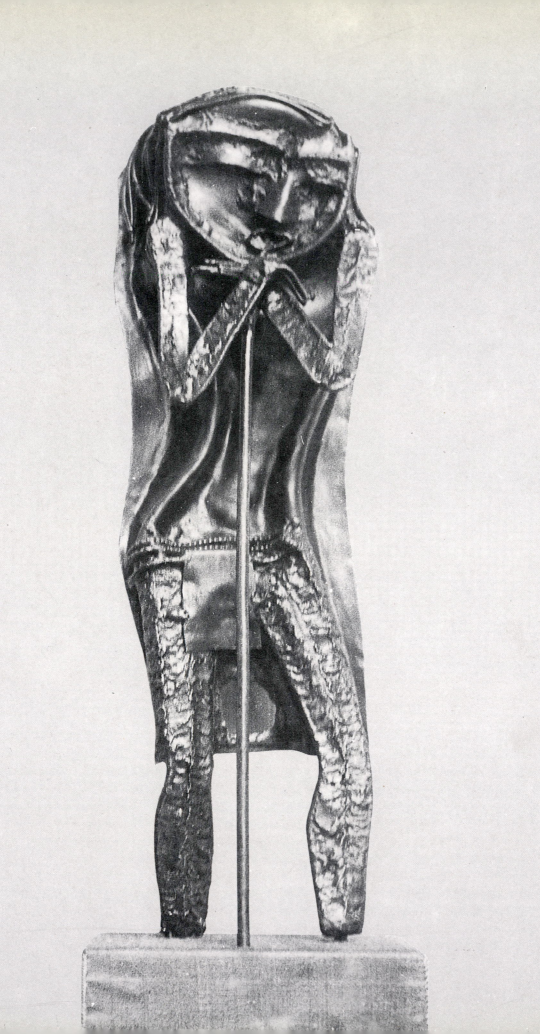

◁ 'Shepherd'
Welded Copper
1964

▷ 'Madonna and Christ'
Oxidized Copper
1964

reached out to his earlier type of rigour in a series of tree shapes he did during the eighties. This was also a time when his work commanded a premium with the buying public. They would have more and more of his well-decorated, quasi-religious, iconic figurations. His sculpture in this phase became elaborate, loosely iconographic, somewhat baroque in comparison with his early work.

Janakiram does not agree with this assessment. 'An artist must be free to change. He must be aware of a public. If he relates to a public it does not mean that he stops being an artist. My work has varied from piece to piece.

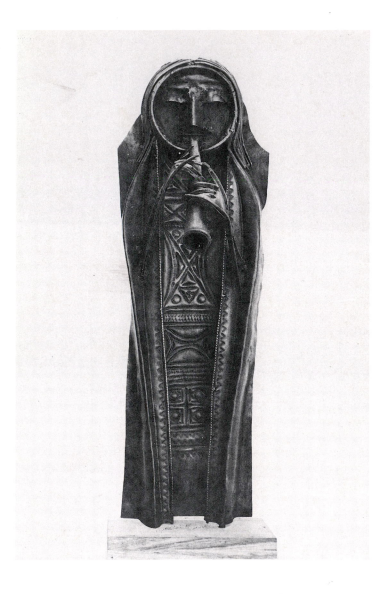

◁ 'Musician'
Oxidized Copper
1975

The medium is the same, the technique is the same; it is hard work, beating the pieces of metal inch by inch, but the outcome is always different. In my mind I am very clear about what I am doing and the moment I finish a work I am very happy about it.' The god-like aura remains: Janakiram, the sculptor, is filled with the special joy, not unmixed with terror, of the creator whose industry can vest inanimate material with life. It makes him both humble and arrogant.

Geetha Doctor

## JANAKIRAM

1930    *born in Madras*

1953    *graduates from the Government College of Art and Crafts, Madras with a diploma in Fine Arts, Painting*

1962    *receives a Diploma in Sculpture*

1964-66    *National Award of the Lalit Kala Akademi, New Delhi*

1965 ·    *Contemporary Indian Art Exhibition, Nairobi, Africa; Paris Biennale*

1967    *Sao Paolo Biennale, Brazil*

1968, 71, 75 78,82    *1st, 2nd, 3rd, 4th, and 5th Triennales, India*

1968    *Exhibition of Contemporary Indian Painting and Sculpture organized by the ICCR in Brussels, Vienna, Copenhagen, Amsterdam, and Oslo*

1973    *25 years of Indian Art, New Delhi; Small Plastics Biennale, Budapest, Hungary Grand Prix at 2nd Biennale of Small Plastics, Budapest, Hungary*

1976    *13th Middelheim Biennale; open-air-sculpture exhibition, Antwerp, Belgium*

1980    *travelling exhibition of the National Gallery of Modern Art in Teheran, Moscow, and East European countries;. Asian Artists Exhibition, Part II, Fukuoka Art Museum, Japan*

1991    *'The Madras Metaphor' exhibition organized by Ebrahim Alkazi at Art Heritage gallery, New Delhi*

# VIDYASHANKAR STHAPATHY

# Vidyashankar Sthapathy

The multi-layered culture of those ancient people, the Tamils, is nowhere more manifest than in Thanjavur and its adjacent districts of the old Chola empire of South India. Long reigns of peace and prosperity fostered the natural piety of a sensitive people. The aesthetic creations were an amalgam of individual worship and community rituals, where art became the offering of mortals to the Immortal. God was himself the supreme artist, dancer, musician, and poet. And poets sang his glory, songsters invoked his grace, dancers—his handmaidens, performed sacred rites. Architects and sculptors vied with each other to build abodes for and forms of Him. Marvels of granite and mortar, bronze and wood survive to this day testifying to the art and science of those master craftsmen. The dim-lit chambers and silent corridors of the temples they built breathe the spirit of that bygone era, of men whose vision embraced excellence. A spirit which pervades a living tradition even today— of ritual worship, of artistic creation and response.

It was this composite culture of antiquity which Vidyashankar Sthapathy inherited from his forebears, all temple sculptors apprenticed in the yard. Their command of the *Vasthu Shastra* is traceable through centuries of creative commitment. They concretized the finite and the infinite within the *Dashamatala* measurements; their craft captured both the real and the unreal in stone, wood, or clay, whether in architectural, sculptural, or iconic representations — indeed, even in humble terracotta figures.

Born in 1938 at Karur, Vidyashankar received his regular schooling and his training in the family art at the temple town of Srirangam. The ambience was conducive to a direct absorption of the living arts as exemplified in the daily and festive celebrations of the great Vaishnava shrine. As the splendidly adorned *Utsava* idols were taken out in procession at appointed times, they swayed to the variagated movements of their bearers, simulating the *Sarpa nadai* (of the serpent), the imposing *Gaja nadai* (of the royal tusker), of the *Simha nadai* (of the lion) while the *nadaswaram* piped age-old melodies, fast or slow, heightened by exuberant percussion. Torches flared, camphor glowed, flowers were strewn, sandalwood paste and rosewater splashed as

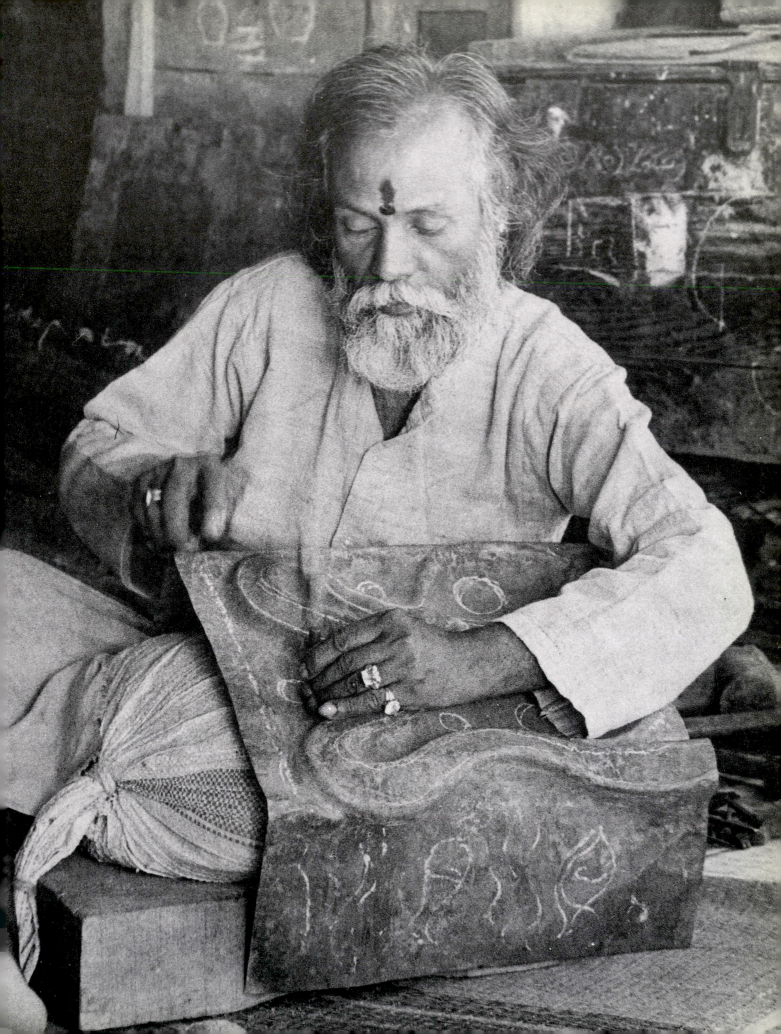

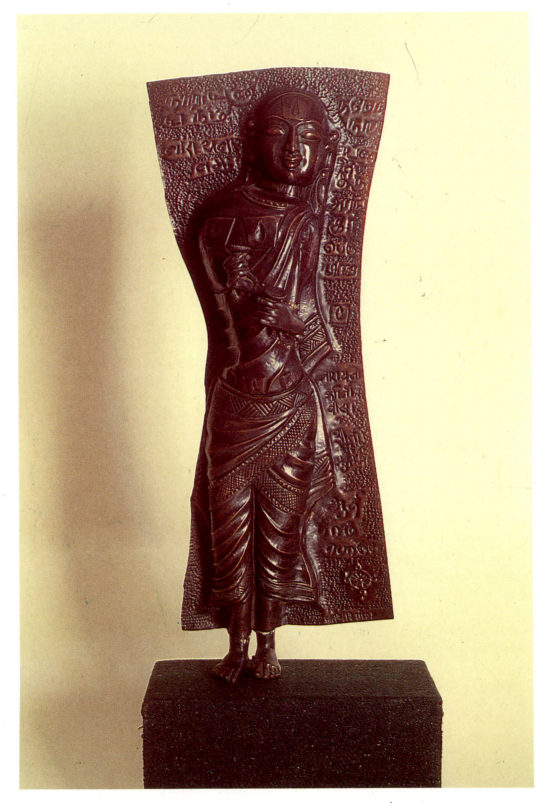

△ 'Alwar'
Sheet Copper and Cast Brass
1992

▷  'Mourner-I'
Copper Repoussé
1963

the priests recited mantras and the devotees chanted the name of the Lord.

There were other fascinating scenes of intense beauty and concentration, as Vidyashankar watched father Gowrishankar Sthapathy, the redoubtable traditionalist, hammering and chiselling pieces of granite and wood, animating them into gods and heroes, intricately patterning their ceremonial mounts and chariots. The father's craft skills and *sastraic* erudition were naturally imbibed by the son. It was strengthened later when the family shifted to Swamimalai. Here he found his clansmen engaged in similar tasks. The growing boy found himself coexisting with divine, demoniac, mythical beings and exotic creatures, all in several stages of evolution from slabs of stone. Dismembered limbs and mould lay scattered through the courtyard where he worked and played. He would be fascinated by the carved expression of faces, or by the diverse *mudra*s of their hands, the many postures and stances. Each variation had an iconographical, symbolic explanation.

He learnt assiduously the technical formulae and the metaphysical conceptualizations of a pre-Christian art handed down through the patrilineal practice of generations. Names remembered go back from father Gowrishankar Sthapathy and grandfather Muthuswami Sthapathy, to Sthapathys Duraiswami, Annaswami, Ramaswami, and Sadasivam of thirteen successive generations. Oral accounts place eminent sculptors of Swamimalai–Aghora Virabhadra Sthapathy and Swaminatha Sthapathy, among his ancestors, as also those nameless descendants of Raja Raja Perumthachan (who had constructed the Brihadishwara temple at Thanjavur). They had left their skills on the granite walls of the Gangaikondacholapuram, Darasuram and Narthamalai shrines. Each of them served the temple with utter dedication through the dynamics of their art.

But Vidyashankar's career took a new turn when he decided to join the Government College of Art and Crafts, Madras. There he was to get his diploma in Fine Arts, Sculpture, and Crafts, specializing in metalwork. In 1968 he joined the Government College of Art and Crafts, Kumbakonam where he is at present an associate lecturer.

In taking these revolutionary steps away from tradition he had been preceded by his great-grandfather, Srividhya Ramaswami Sthapathy, who had headed the Metalwork Department of the Government School of Art and Crafts Madras, in the 1880s, retiring with a pension and a commendation from Queen Victoria.

At the Madras School of Art and Crafts the influence of Devi Prasad Roy Choudhury was pronounced while Principal K.C.S. Paniker and instructor

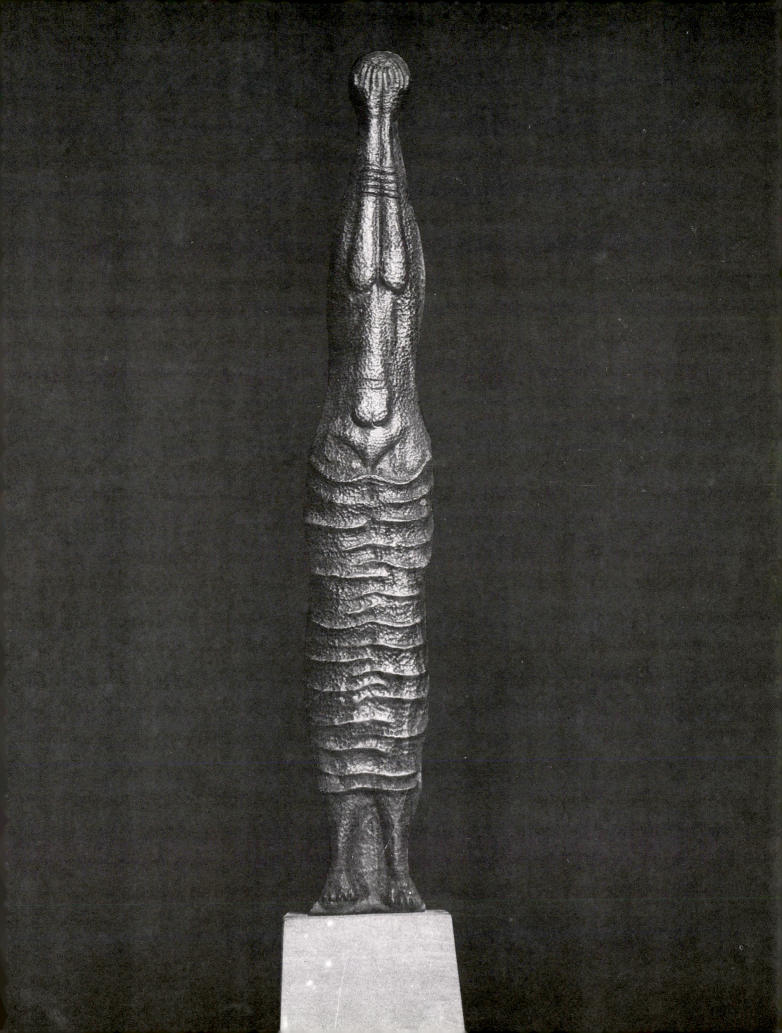

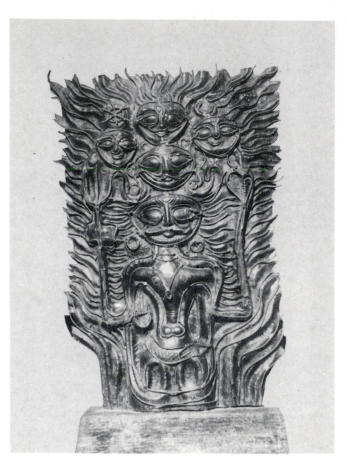

‹  'Agni'
Welded Copper
1971

▷  'Mangai'
Copper Sheet and Brass Cast
1989-90
Collection: National Gallery of Modern Art,
New Delhi.

S. Dhanpal were no less influential as exemplars of the modern genre. Paniker was quick to spot the youngster's intelligent movement towards a blend of the old and the new, especially in metalcraft. Encouraged by the masters of the school and by fellow artists like Adayar K. Sreenivasulu, Vidyashankar's experiments grew progressively bolder. While still at college he began free-standing work in beaten sheet metal which, when straightened out and displayed, combined abstraction and ornateness; played with optical illusions of hidden dimensions. It prefigured, explored, and expanded the concept of frontal sculpture and became the fountainhead of a new Madras metaphor.

Younger contemporary sculptor S. Nandagopal is quick to declare, 'Where would I be without the inspiration from Vidyashankar Sthapathy's work? He is undoubtedly our forerunner in frontal sculpture.' Critics and artists admit that the hints and glimpses of frontality in the work of artists like Dhanapal, Kunhiraman, and Janakiram may not have developed into an identifiable,

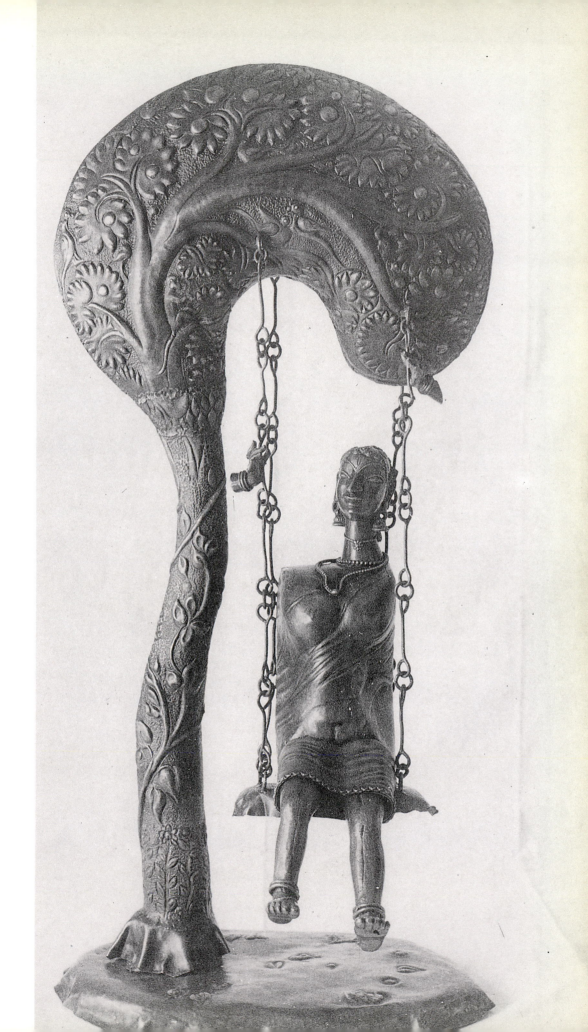

▷ 'Tree'
Welded Copper Sheet
1985

full-fledged mode without Vidyashankar Sthapathy's pioneering. It led them 'to rid sculpture wholly of its massive body and to move·it daringly towards pure presence'.

Vidyashankar's artistic legacy had no independent origin, in inspiration, execution, or in the response it evoked. The *Vishwakarma* craft glorified religion; it also provided a system of support for the elaboration of rituals. The burden of this heavy weight was lightened by the Sthapathy's love of the virile folk arts—flexible, adaptable, and insouciant; throbbing to the pulse of the people. He interiorized the rural and visual expansiveness of the rural landscape, where the village greens leapt to life around the jaunty colours of the *Kavadi attam*, the *Karagattam*, the *Poikkal kudirai* or the *Naiyandi melam*, where the *tirmiri, udukku, suddha maddalam, ekalam,* and *sanku* thrilled the heart by their singular modalities at the festivals of *grama devata* — Mariamman, Muniswaran, Ellai Amman, or Ayyanar. These hewn or baked deities were often surrounded by large terracotta animals and attendant gods of arresting proportions and distortions. Their very forms and rites of workship evoked a fearsome awe in the viewer. Young Vidyashankar became so enamoured of this parallel culture that he often joined the dancing, anklets on his feet, garlands round his neck, his forehead generously smeared with vermillion.

Commercialization and Western influence of the modern period had proved inimical to this virile legacy, now attenuated to a vague romanticism and decorative sterility. The renaissance, catalyzed by the nationalist upsurge, sought to regain its lost virility. Going beyond selfconsciousness or artificial Indianness, it passed on to pure sculptural expression. Moving away from the metaphysical, sacramental, and symbolic concerns of a traditional rite-ridden culture, the artists of independent India sought to inscape the non-objective,·to arrive at an abstraction of form and image. They worked towards the autonomy of creative manifestation in stone, metal, wood, and other  materials adapted to suit their purpose. Sculpture would not point to an end beyond itself; it would not subserve theology, mythology, faith, and philosophy. On the contrary, other systems of knowledge and experience·of representation and ideation would be tapped to reinforce the sculptural idiom, and the unique aesthetic experience it generates.

One area of departure was explored in the development of frontal sculpture — a new and unique expression of the modern spirit. Though three-dimensional, they are approached and viewed from only one angle: the front. Distanced into the sacred sanctum, framed in darkness, and circled only by lamplight, they acquire a pictorial quality.

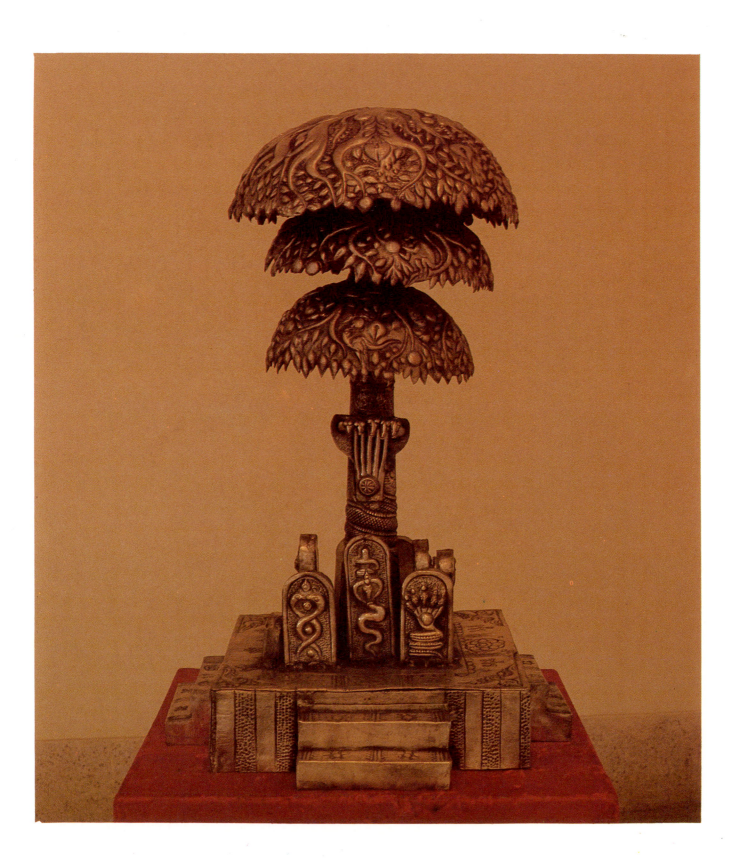

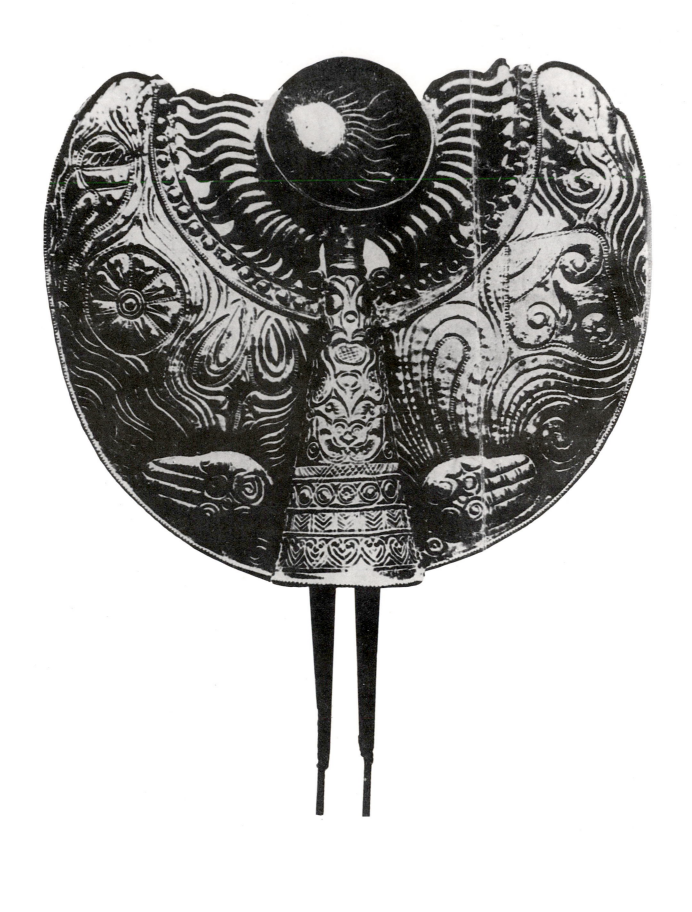

◁ 'Deity'
Welded Copper
1972

▷ 'Mourner-II'
Copper Repoussé
1963

▷  'The Swing'
Welded Copper Sheet
1992

Besides, the deity revealed during the worship is not a single figure but one made up of several component parts like the metal coverings for the chest, hands, feet, the headpiece and crown, the weapons and jewellery, the constumes and flowers, all compacted into a frame. The impact of depth-sculpture is arrived at by piecing several things together to make a new whole. This is even more obvious in the *Utsava Murthi* of the temples, those gorgeously-decked metallic icons, taken out in ceremonial processions. Their high-held pedestals as they are carried through the streets emphasize frontal viewing as the proper practice for the devotees.

Frontality is also indicated in the long and remarkable tradition of relief panels, friezes in temples all over India, as at the rock-cut temples of Ellora and Mahabalipuram, where most of the mythic episodes are depicted in various sizes on the granite walls which permit only viewing from the front. This is also true of the sculpted figures placed in the *kostha* niches in the temple walls.

Many sculptors of Modern India recognized the fresh possibilities for working and viewing in the frontal mode, as did Dhanraj Bhagat who experimented in Delhi with images and shapes beaten on sheet metal in the late fifties. He made a few such standing pieces, though most of them were mounted on wood. His works are interesting as early attempts, powerful but in a foetal, seminal sort of way.

Soon after, independently of Bhagat but perhaps influenced by him, a group of artists in Madras began to take an interest in the traditional methods of craft such as repoussé, a technique as old as Egypt. The Madras artists embellished their carved sheets with bits of metal—copper, brass strips and rods—like the assemblage of parts in a temple deity, and tried to achieve a different dimension from the blend.

Since frontality in sculpture arose out of a religio–ritualistic necessity in ancient and medieval India, Vidyashankar Sthapathy, raised and trained in those traditions, became a natural pioneer in the attempts to transpose it to a contemporary context. The idea of attention from a single angle of worship intrigued him enough to adopt a secular approach to explore its artistic potentials.

Recollecting those times, Sthapathy says :

I had never been interested in pure abstract forms, but I did want to break away from the old moulds and find myself in the modern genre. But my inspiration still comes from the traditional and folk strains of sculpture, as also from the wealth of music, dance, and painting in South India. I tried to absorb their essence into my work. *Vedicagama Shastra, Purana*

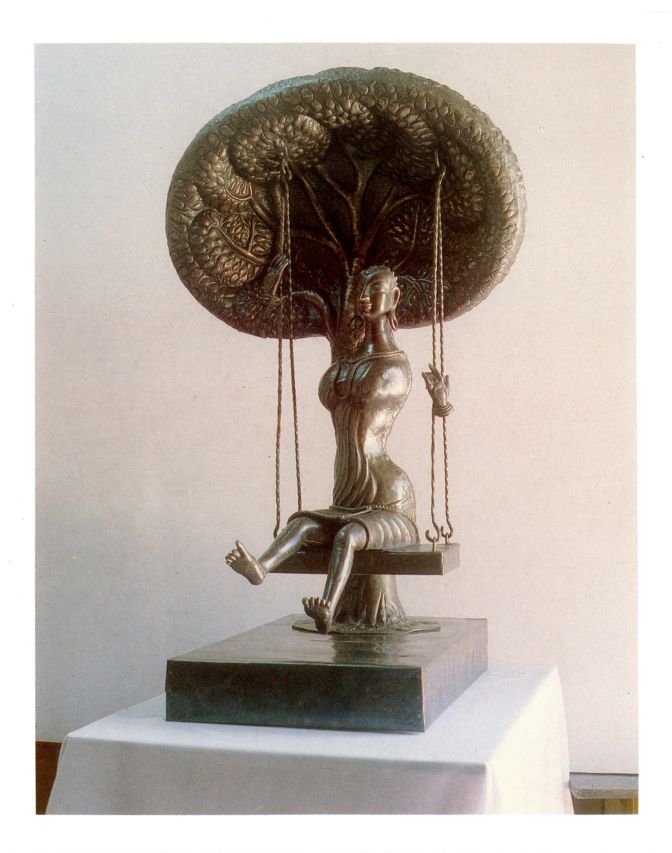

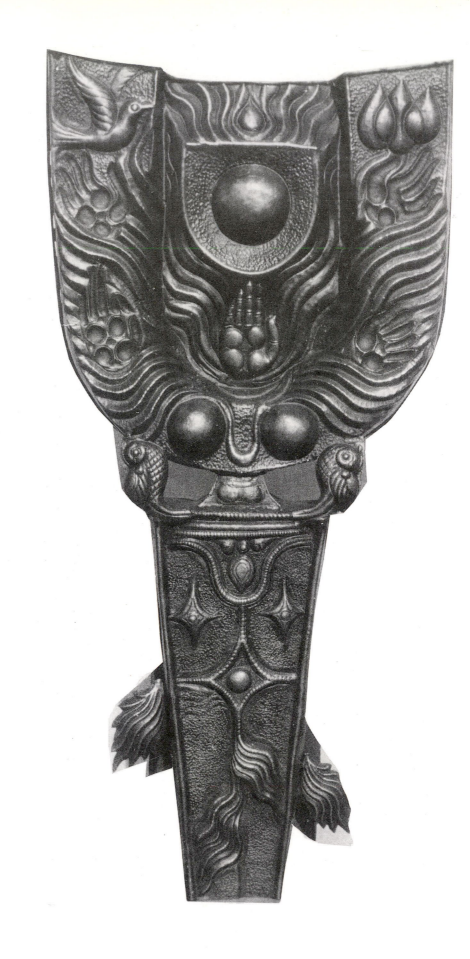

'The Symbol'
Copper Repoussé
1975

'Krishna'
Silver Plated Copper
1990
Collection: O.P. Jallan

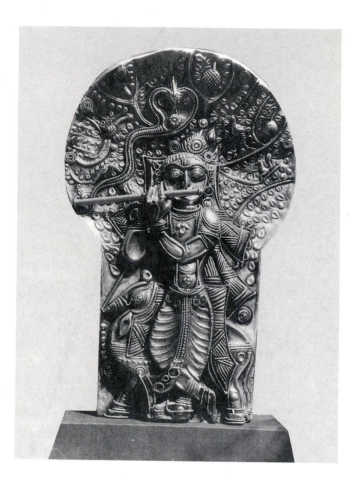

*Ithihasa Tatva,* and *Rasa-siddhantha* are likewise at the very base of my new directional findings which have aimed at their synthesis through 25 years of experimentation. For example, I was the first to introduce iconographical and epigraphical elements in sculpture. My shapes and forms are modern, but my subjects are drawn from the rich resonances of the past. I try to evoke those resonances in everything I do, whether in my imaging of Karaikkal Ammaiyar, Vinayaka, Kumara, or the rain goodess Renuka Devi.

He continues after a pause:

Other modern sculptors have to go to a temple to see the deity or a frieze or a *vahana*, to discover the number of hands or the kinds of symbols accompanying each concept. But all those details are imprinted in my mind by hereditary transmission, so that I can mentally visualize what I want, and go on to achieve it in my medium. I know the tantrik concepts and the *Dhyana Sloka* of each image as well as I know the methodology of their execution in stone or metal or wood. This gives my compositions a proportional accuracy and balance which are missing in the works of many other modern sculptors. I believe that even distortions must follow a norm to impart repose, equipoise, and vibrancy. They transform your art object into living sculpture.

▽  'The Woman'
   Copper Repoussé
   1964

The continuity of his hereditary profession, although deviating from the practice of his forebears, is assured as son Raja Ravishankar follows in his father's footsteps. But with all these achievements, would Vidyashankar Sthapathy's adventures in the modern genre have found favour with his father, Silpa Kalanidhi Gowrishankar Sthapathy?

In response, Sthapathy says:

If I had explained my impulsions rationally, he might have understood my work. Traditionalists will never accept anything other than the art made according to the traditional canons. There is truth, sincerity and justice in their commitment. Why, without that strong foundation in the past, there can be no present — the new will have no meaning, no existence, no beauty. But I cannot live in a confined past. I see changes everywhere and I want my work to reflect those elements of change; I want it to be part of that change. I don't want to live in yesterday's dreams. I want to stimulate the reality of the present in myself, in my thought and in my work.

<div align="right">Gowri Ramnarayan</div>

## VIDYASHANKAR STHAPATHY

1938   born in Srirangam, Tiruchchirapalli

1962   diploma in Fine Arts from the Government College of Art and Crafts, Madras

1976   Bombay Art Society Award

1989   Regional Centre Art Exhibition of the Lalit Kala Akademi, Madras. 3rd Havana Biennale, Cuba

1991   'The Madras Metaphor' exhibition organized by Ebrahim Alkazi at Art Heritage gallery, New Delhi

1993   National Award of the Lalit Kala Akademi, New Delhi

# DAKSHINAMOORTHY

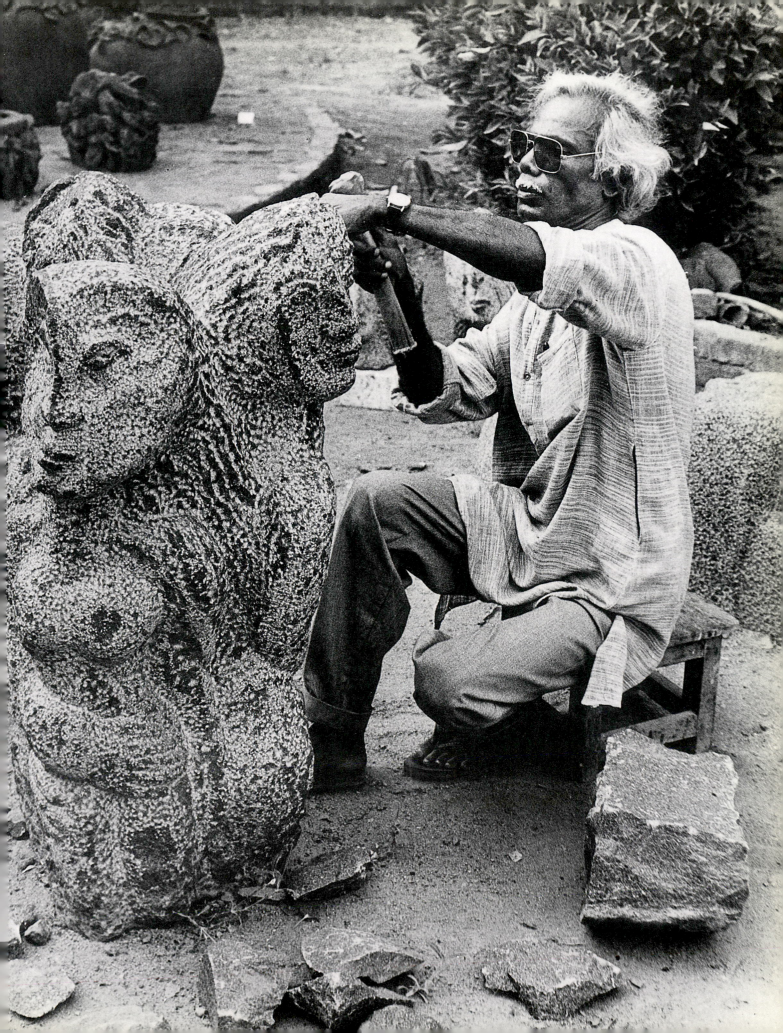

# C. Dakshinamoorthy

Chinaraj Dakshinamoorthy was born in 1943 at Gudiyatam, a small town with a big reputation for textile trade. It is in the North Arcot Dr Ambedkar district of Tamil Nadu. He comes of a humble, lower middle class family with no claims to artistic or intellectual lineage, though his father and one of his elder brothers are said to be sound Sanskrit scholars. But Dakshina, one of Chinnaraj's seven children—three sons and four daughters—had an irresistible impulse from the age of seven to express himself through visual images. So he found himself doodling or splashing colour on whatever surfaces he could lay his hands on and his elders were understanding enough not to check this natural urge. He had an indifferent schooling. Because of his lack of interest in subjects other than drawing and printing he could get only as far as the SSLC examination which in those days was sufficient qualification for eligibility to the Madras School (now Government College) of Arts and Crafts.

Dakshina's general schooling was thus no success story, but it was beneficial to him, though only indirectly, in one important respect. On his way to the local Municipal High School, he would stop by a hut and eagerly watch a potter at work. Wholly entranced by the twists and turns that breathed life into the forms whirling on the wheel, he would himself pick up some clay and fashion it into tiny figurines to the delight of the potter. Dakshina would hand over his figures to the potter and request him to bake them. This became little Dakshina's daily routine. When he was in the fourth form, drawing and painting were taught as optional subjects. Nothing made him happier. He spent three hours daily upto the sixth form in these classes. His sympathetic drawing teacher gave him every freedom, with the result that Dakshina used whatever medium that came his way — watercolours, oils, pastels and enjoyed himself sketching from life or nature, outdoors or indoors. Impressed by Dakshina's work, the teacher advised him to try for admission to the Madras School of Art and Crafts.

In July 1960 he joined this nursery of many of South India's greatest artists, with K.C.S. Paniker as its charismatic Principal. During his vacations at

△ 'Head - 7'
Granite
1992

▷  'Head - I'
    Granite
    1992

Gudiyatam, Dakshina had the benefit of advice and guidance from his senior, A.P. Santhanaraj who used to go there from Thiruvannamalai for his summer holidays. Though Paniker did not teach Dakshina, he used to watch him at work and offer very perceptive comments which proved extremely useful in his artistic development. Among Dakshina's teachers, the ones he remembers with gratitutde are H.V. Ramgopal, Anthony Doss, and S. Murugesan. He learnt from them and the elder, A.P. Santhanaraj, how one could penetrate with line and colour and  bring character, personality, and feeling to life.

Completing his six years' course with distinction in 1966, he took his diploma and was now ready for a professional career. At this stage, concerned about the small number of students in the sculpture classes under S. Dhanapal, Paniker suggested he try his hand at sculpture. Accepting the advice he decided to attend Dhanapal's classes just for one or two hours a day to acquire basic knowledge and to get a feel of the material. He would play with clay, cement, bronze, plaster of Paris, and whatever other material came his way and feel his way with his fingers to model lively forms. In 1966, he acquired land at Cholamandal and began to live and work there up to 1969. One day, S. Kanniappan suggested that he join the Madras School as a casual student and attend ceramics classes. Dakshina thus did a brief, informal one year's stint as a student of ceramics. In 1970, he was appointed instructor at the Ceramics Department. From there he moved to yet another discipline: print-making. As a British Council scholar, he did an advanced course in it at the Croydon College of Design and Technology (1978-9) under Dennis Masi, specializing in lithography and screen printing. Working hard for eight hours a day on all days except Saturdays and Sundays, he distinguished himself and won the plaudits of his Principal. Before leaving Croydon, he visited Italy, Greece, Switzerland, and France, looking at great works of art and learning from them on his own.

Success came to him early, both as an artist and as a professional. Even as a student at the Madras School of Arts and Crafts he was able to sell his paintings. Indeed, he first participated in the National Exhibition when he was a second year student. In 1985 he won the National Award. He held his first one man show in 1966, at the Local Library Authority's building at Mount Road, Madras. From then on he exhibited extensively at prestigious exhibitions in India and abroad, which included the Fifth and the Sixth Triennale—India and the Budapest Biennial for sculptors.

Among Indian painters, Dakshina responds to A.P. Santhanaraj because of

▽ 'Head - 2 '
Stone and Bronze
1991

▷ 'Head - 3'
Granite
1993

◁ 'Head - 8'
Granite
1991

the amazing penetration and fluency of the latter's drawing. Among sculptors, he admires Dhanapal for his 'forcefulness, bold touches and dynamism'. Among the Western masters, Dakshina feels closest to Paul Gaugin. The moment Dakshina saw Gaugin's wood carvings and terracottas in Paris he came under the great Post-Impressionist master's spell. That combined with his love for indigenous workmanship awakened in him by the historic Mahabalipuram sculptures. He was deeply drawn to the unique technique used by the great unknown masters, of leaving the rough surface untouched, and carving exquisite figures that retained the grain of the stone.

Dakshina does not seek any role models for his inspiration. He says: 'My inspiration comes from the people — as groups or as individuals. I get ideas by watching them closely — their moods, their postures, their gestures, etc. As for my visual vocabulary, it comes from our Ayyanar figures and African sculptures.'

Dakshina's sharply sensuous and evocative art is very individual and exceptional. What makes it exceptional is its most personal blend of tradition and modernity, of the discipline of the one and the freedom of the other. He draws freely from ethnic iconography and imparts to it a strong contemporary thrust and finish, making it figurative without being illustrative. Though sculpture, particularly terracotta, is closest to him, he can express himself in several other media with equal verve. What makes his versatility readily acceptable is its broad virtuoso quality that strengthens and sustains his workmanship. Whatever he does, he does extremely well because he is not sparing either in technique or conviction. That is why every work of his is strong and true, no matter what the medium.

Dakshina's paintings and sculptures emphasize his strong affinities with tribal art in their basic lines and contours. The affinity is clear in his compositions which are forceful because of their spontaneous directness and simplicity, achieved through discipline and thorough craftsmanship. He has a free feeling for the material he uses, be it paint, metal, clay, or stone. He undersands it thoroughly, turns it upside down, and senses every aspect of it. Then he begins to work it as his slave and it obeys his every bidding.

His colours are earthy and his forms primitive. And yet his work can speak to men and women of high fashion because of the forceful elemental feeling it evokes and its overall, absolutely disarming, quality of openness. His paintings and sculptures are, therefore, almost live commentaries on the first principles of art and candid reflections on the nuances of the basic creative urge. His art is in place not only in museums and galleries but in drawing rooms

▽  'Bird'
   Granite
   1992

▷  'Head - 4'
   Granite
   1991

▷  'Head - 9'
Granite
1989

and dining rooms, out in the open and also at street corners. The art of today has almost lost its social connection because of its highly personalized idiom. But Dakshina manages to reveal as much of himself through his art as possible, and at the same time, makes it socially compelling. This is because the vital roots which he humbly shares with the common people around are the focus of his work. It is artists like Dakshina who can, to quote Arnold Hauser, 'extend the horizon of the masses as much as possible, so that their share in creative art can be increased and deepened'.

Though perfectly comfortable in any medium, all of which he can handle with exceptional skill and sensitivity, he is primarily a sculptor with an instinctive sense of form and with a feeling for his material. His stone sculptures are vibrant with elemental energy and raw sensuousness. That would bring to one's mind Michelangelo's lines:

With chiselled touch
The stone unhewn and cold
Becomes a living mould
The more the stone wastes
The more the stature grows.

Smoothness, slickness, suavity — such buzz-words for success are not for him. He believes in turning his virile aesthetic sensibility into exuberant creativity, keeping the forms he evokes simple, direct, open, and immediate; making an impact on the spectator despite their roughness which springs from the material he uses.

Dakshina makes sculpture because nothing else excites him as much in his life. Whatever problems he encounters in the process of making it are overcome with a deftness of wit and skill. His sculpture is a personal statement. But it is not private. It is intended to communicate, to appeal to sympathetic and large-hearted people. He firmly believes that his sculpture, if not now, will some day relate fully to people.

His preference is for stone which he finds very fulfilling to handle. He first draws an outline in red oxide direct on stone and begins to do the cutting and the carving. He does not need helpers. Terracotta and bronze casting need his attention at every stage and the results of his efforts are visible only in stages through various processes, while in stone he sees figures coming alive as he works. That is just so reflective of his personality and of its whole manner of expression.

A.S. Raman

▽ 'The Woman'
Granite
1992

## DAKSHINAMOORTHY

*1943*      *born in Gudiyatam, Tamil Nadu*

*1966*      *graduates with a diploma from the Government College of Art and Crafts, Madras*

*1967*      *takes part in the Travelling Exhibition of Indian artists held in various European cities*

*1973*      *is one of Seven Indian Artists exhibiting in Australia*

*1977-8*    *does post-graduate work at Croydon College of Design and Technology on a British Council Scholarship*

*1982*      *9th International Triennale of coloured graphic prints*

*1983-5*    *Junior Fellowship awarded by Department of Culture, New Delhi*

*1985*      *National Award, Lalit Kala Akademi, New Delhi*

*1986*      *Triennale, India*

*1987*      *7th International Small Sculpture Exhibition, Budapest, Hungary*

*1989-91*   *Senior Fellowship conferred by the Department of culture, New Delhi*

*1990*      *3rd International Asian–European Art Biennale, Ankara, Turkey.*

*1991*      *Triennale, India; 'The Madras Metaphor' exhibition organized by Ebrahim Alkazi at Art Heritage gallery, New Delhi*

▽ 'Rider'
Welded Copper
1972

▷ 'Kite'
Copper Plate with Hinges
1987

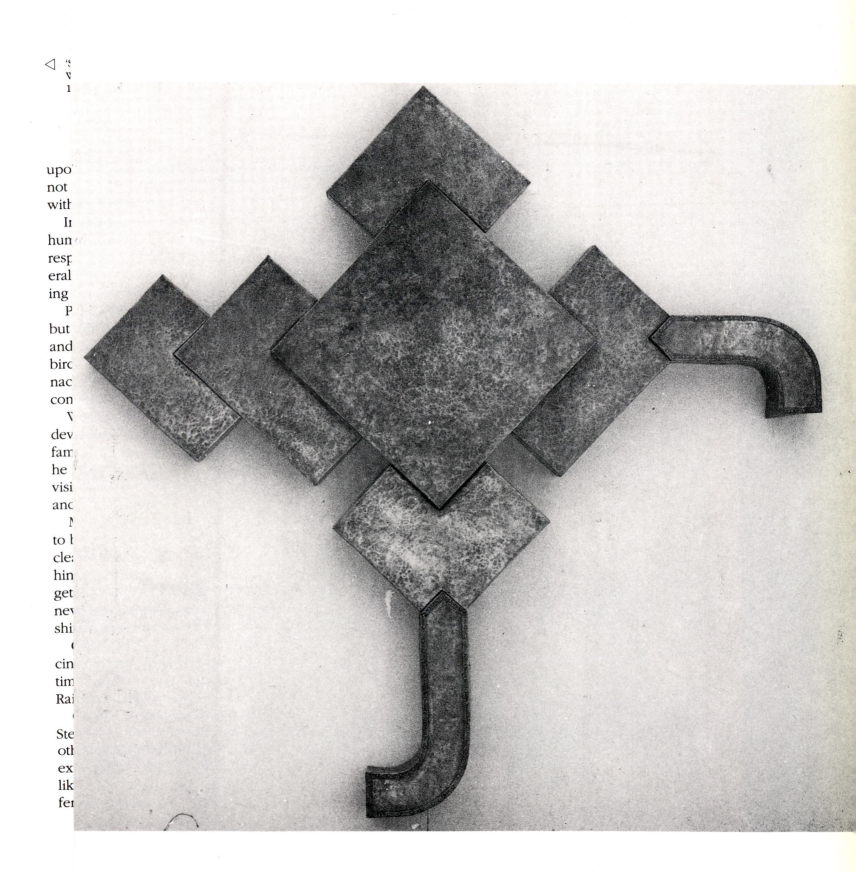

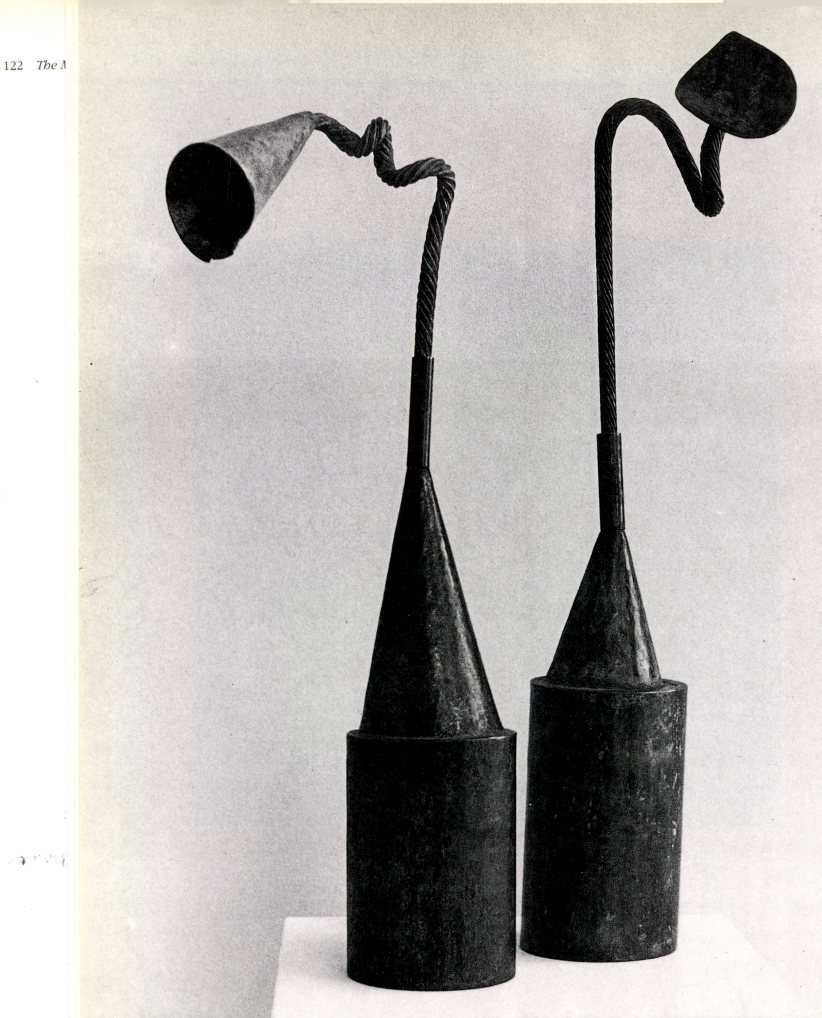

◁  'In Bloom'
    Copper
    1993

▽  'Performer'
    Copper
    1985

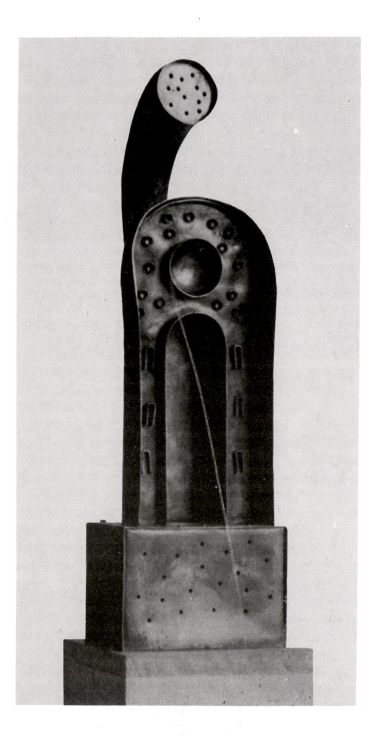

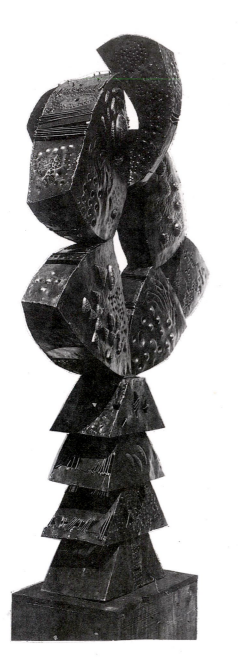

▽  'Tree'
Oxidized Copper
1975

Memories challenged him: childhood moments spent by the cool temple tank near his home — a tank which his son would never see, for it had dried up years ago. As he read of India's green past, of its shrinking forest cover, and of the Indian 'Hug-the-Tree' movements, he decided to work, through art, for a greener future.

Thus his newest sculptures, 'Trees' and 'Salute to Old Growth', explore themes of forest loss, East and West. To make them, Paramasivam collected used, recycled wires from the stockyards of Seattle's public utility company.

Thick copper wires or hollow tubes emerge from welded copper cones, then turn into shapes suggesting the sprouts of living trees. The riveted cones touch the ground, supporting growths of copper pieces curved or flattened, copper wires twisting, circling, winding — all almost alive. In this series, one finds both single pieces and pieces grouped in sets of five or more. The sets, which give an impression of a forest, can be arranged and changed by the artist, to show movement and change.

Movement and change — Paramasivam's sculptures have for many years seemed ready to move: to fly, to walk, to sway, to enclose, to grow.

Paramasivam has not stood still, and neither has his work. And the years to come will surely call forth still more change from the hands of this sculptor. For he is ever eager to try new things, to seek challenge, to follow the advice of his favourite saying,

Why not ask for an elephant?
If you succeed, you get an elephant.
If you don't, you lose only a few words!

<div align="right">Cathy Spagnoli</div>

## PARAMASIVAM

1942    *born, Gudiyatam, Tamil Nadu*

1961-7  *receives training at the Government College of Art and Crafts, Madras*

1965    *becomes a life member of Cholamandal Artists' Village, Madras*

1968    *Prize in National Exhibition, Kerala*

1975    *Exhibits at III Triennale—India, New Delhi*

1981    *Prize for Sculpture, Mercer Island*

1982    *Prize for Sculpture, Ocean Shores; Pelican Bay Gallery, solo show, Seattle*

1983    *Greenwood Gallery Downtown, Seattle*

1988    *Bumbershoot, Show, WA; Seattle Urban League, WA; International Art Show, N.Y. ; Mercer Island Visual Arts League, WA; National Art Exhibition, New Delhi; Tibals of Water Street, Pt, Townsend, WA.*

1989    *Honourable Mention, Mercer Island*

1990    *Show in Osaka, Japan; 'Metalist Conflux', Pratt Gallery Group Show, WA; Pacific Northwest Art Show; Bellevue Art Museum, WA; International Art Show, Whatcom County Museum, WA*

1991    *Show at Chola Gallery, Madras; Madras State Lalit Kala Akademi Annual Show; 'Madras Metaphor' exhibition organized by Ebrahim Alkazi at Art Heritage gallery, New Delhi*

NANDHAN

▽ 'Acrobat'
Terracotta
1992

▷ 'A Form'
Granite
1993

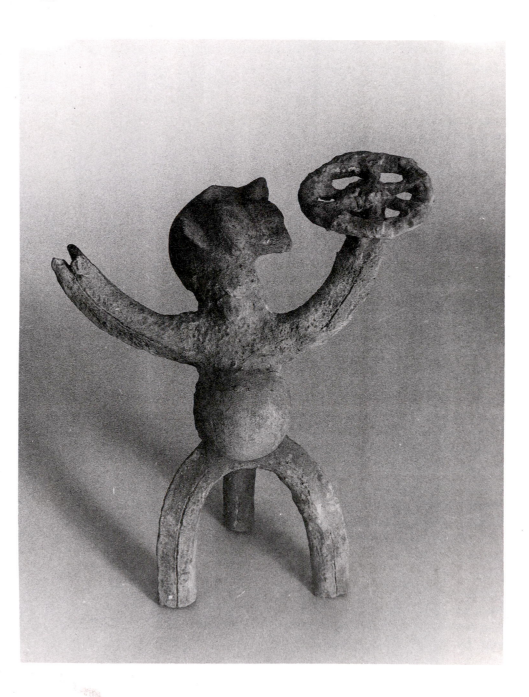

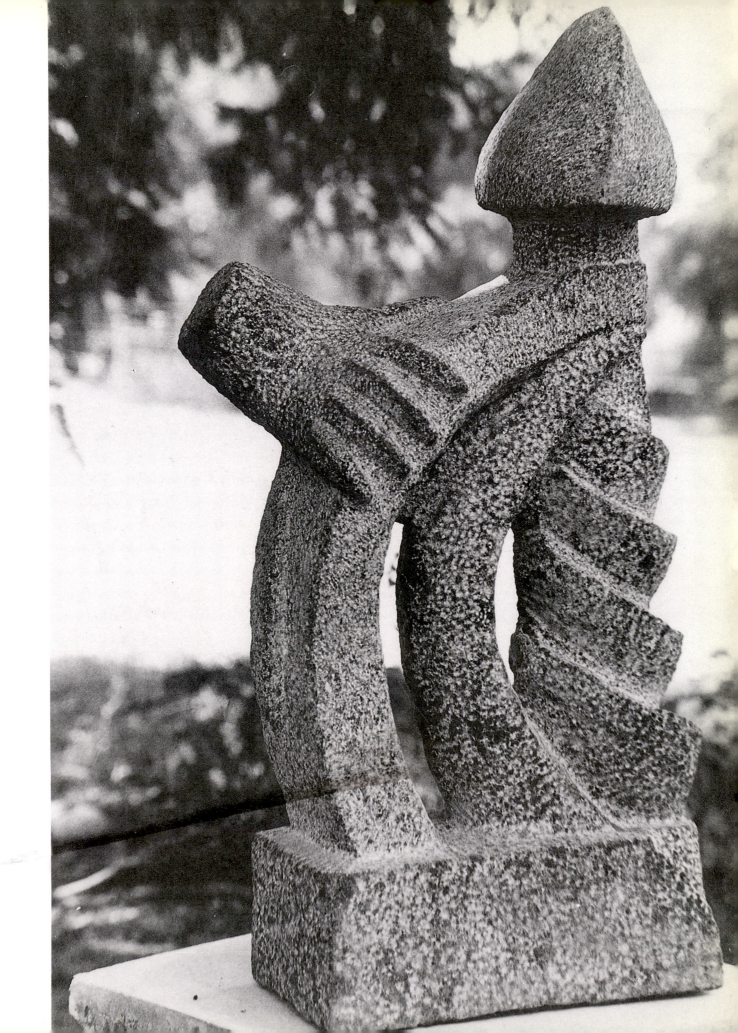

Ganesha in particular. The deity like form which harks back to the traditional iconic image, stretches its arms outwards, away from a head split into two tympanic halves in such a way that the seeds of mysterious thought may spill over in some extremely painful, self-destructing exclamation. In earlier studies he would inscribe the mysterious texts on the limbs of the compositions. But as he worked on, it got assimilated into the rhetorical design of the sculpture. The end result turned out to be in line with the frontal tradition of the classical South Indian bronzes and it won him the National Award.

Presently, Nandhan's work is in granite, the pock-textured solid medium which one has to chip and carve. 'I have been sculpting since 1969', says Nandhan :

With granite, I have learned that it sometimes takes one, two, even three months for me to know what the stone will turn out to be. Suddenly, almost by accident, when you are working on it, it takes a shape and dimension of its own. Granite! It lasts as long as life lasts! Wood lasts for a long while too. It is important to me that my work is lasting. Terracotta crumbles to earth. It doesn't last. Clay is soft. You add it on, unlike wood or granite which you have to carve to make forms. Yet, between doing other sculptures, I use clay to keep my mind and hand moving. In a way, then, all my sculptures are inspired by clay.

As for bronze, Nandhan feels inhibited by the method of working it. 'You know' he says, 'a wax mould is made and then the bronze is cast. In the process it is as if a wax sculpture is made by us while the rest is done by the moulders. It makes me feel that it isn't entirely my work.'

Nandhan who has moved to a distinctively personal idiom in sculpture does not feel part of any movement, including the one in Madras which was in full swing during his formative years. 'No I am not part of a Madras movement or anything', he demurs, thinking it over, 'I think all art moverments are universal, though an individual's work may seem to be influenced by the immediate surroundings or environment. That tree outside my window is part of my life in Madras. Wouldn't it look different if it is transplanted in America? It is the same with movements. Our art has to relate to our soil, our blood, our culture. Anything transplanted from alien soils will not seem right in our context'.

But living and working at Cholamandal along with other sculptors and painters could possibly affect his work even if this does not amount to being part of a school or movement. About the artists' community there, he says, 'We see ourselves as individuals now, but only history will tell if we are all part of single stream, school, or movement. Nandagopal works here, so do I.

▽ 'Movement of Lines'
Green Granite
1991
Collection: National Gallery of Modern Art,
New Delhi.

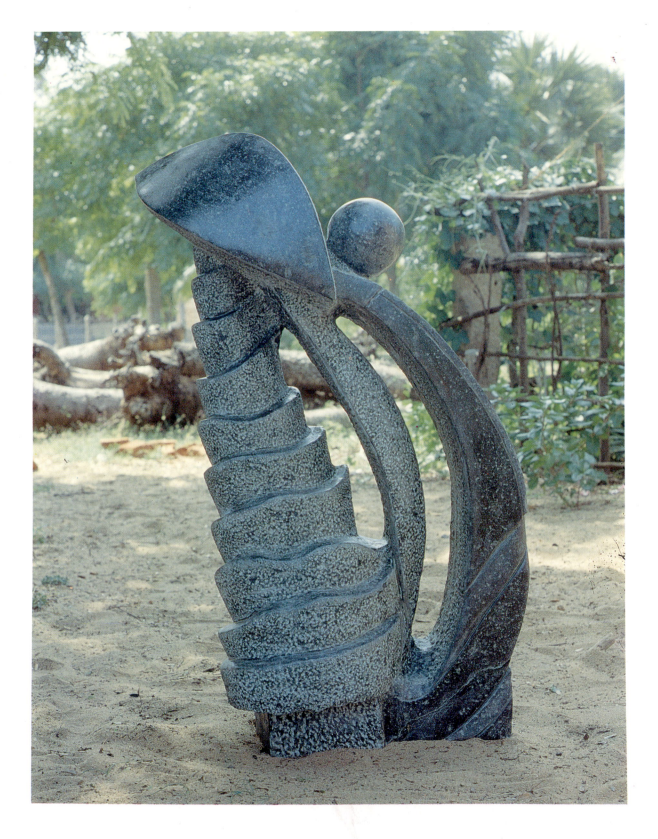

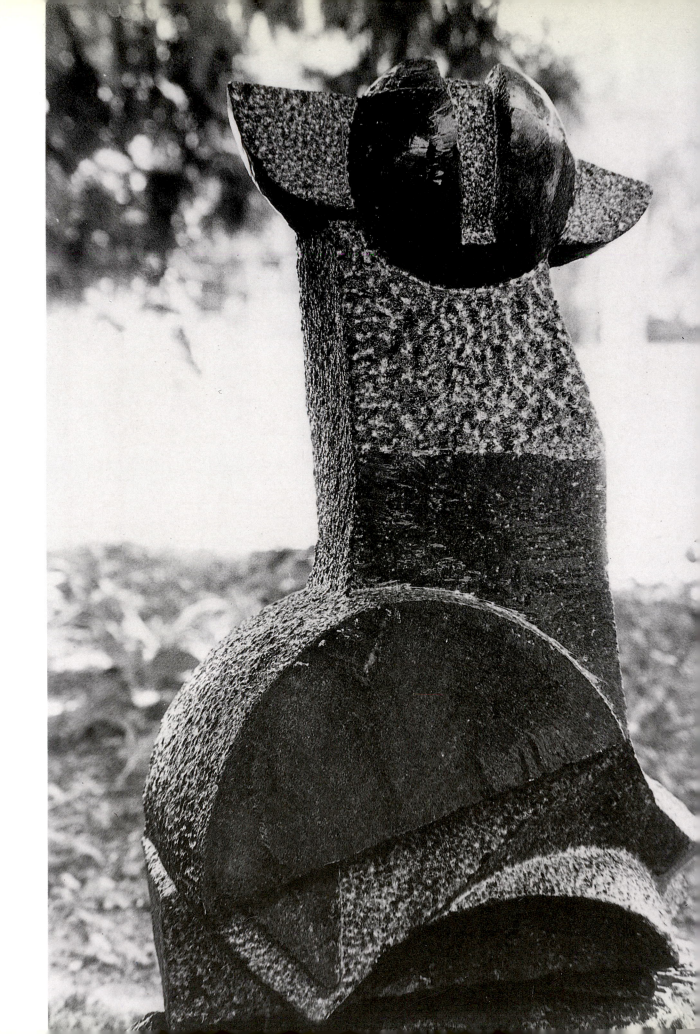

◁ 'Cat'
Granite
1993

▷ 'Deity'
Copper  Sheet Welded
1991

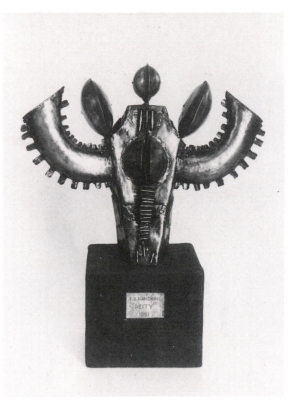

Only 500 years from now will the relationships between us become completely clear. Yet when artists live with artists, as we do here, it helps us subconsciously to watch others, to see their work, and to talk to them. It is like a tree growing in rich soil which will not grow at all if it is planted in cement.'

The wondering child in him, which looks out ever so often through the terracotta masks he keeps making, is perhaps his closest companion and self. It makes him feel completely at home among children who are naturally curious but completely unschooled in art. To participate in terracotta camps and workshops for children is something which gives Nandan great pleasure.

His terracotta masks, justly famous for their distinctive characterization, have often been used by local schools in dance and dramatic performances. Naturally sensitive to the basic drives of the child, the sculptor is a popular teacher at schools. 'With the child, real teaching comes from releasing what is within the young self. Besides that, what is it that I can give them?' muses Nandhan. 'I can only tell them: don't use the knife there, don't use water now, don't....

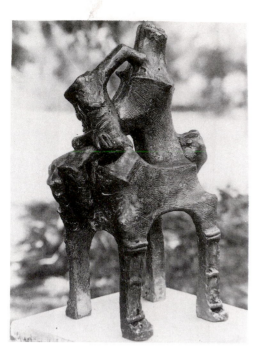

◁    'Harbinger'
Bronze
1985

At a  camp, I start working on a figure with clay, and soon a child comes to me with a creation — an elephant, a child, a bird. These figures may only be ten to fifteen percent realized. It is then up to me to help fulfil the dream locked within each child', says the sculptor in an unsuspectingly autobiographical vein.

The child's freshness of mind is something the artist aspires to all his life. Amidst children, his skill and stature, he feels, are of no help at all. 'Yes, like Picasso, I feel I have so much to learn from children. At my camp I realize that they love playing with clay because both their minds and their hands are involved', Nandhan reiterates.

Perhaps all of these in an undifferentiated way describe the child in him, his self which he refuses to overcome. His certitude about his sculptural direction, his balanced feelings about the successes and pitfalls of artistic existence, his simplicity and sharpness of expression, all make Nandhan a stongly native and authentic personality in the world of modern Indian sculpture. For, at the core of this unusual artist, is the humble, professional belief that he has lived by all these years. Reluctantly, masking himself protectively,  he concludes:

What inspired me to choose sculpture? I discovered early that it is very difficult to make a living by painting. With age, inevitably, your eyes will dull and your ability to capture colours will fade. But with sculpture there is no handicap. Even a blind man can sculpt.

Aditi De

*NANDHAN*

1940    *born in Madurantakam, Tamil Nadu*

1965    *becomes a life member of the Cholamandal Artists' Village*

1968    *diploma in Painting and in the Advance course with distinctions from  the Govern-
ment Colege of Art  and Crafts, Madras*

1972    *experiments with, and starts sculpting in clay, sheet metal, bronze, brick, wood, and
granite*

1976    *Taj Coromandel Hotel, Madras on the occasion of the 25th International Pugwash
Conference; National Exhibition, Lalit Kala Akademi, New Delhi*

1978    *'40 Artists of Madras', organized by the British Council, Madras*

1988     *Asian Art Biennale, Bangla desh*

1989    *Rashtriya Lalit Kala Kendra, Calcutta, on the theme of 'Sculpture on Nehru'*

1990    *International Exhibition of Asian-European Art, Biennale, Ankara, Turkey*

1991    *'The Madras Metaphor' exhibition organized by Ebrahim Alkazi at Art Heritage
gallery, New Delhi*

1992    *awarded the National Award of the Lalit Kala Akademi, New Delhi*

# NANDAGOPAL

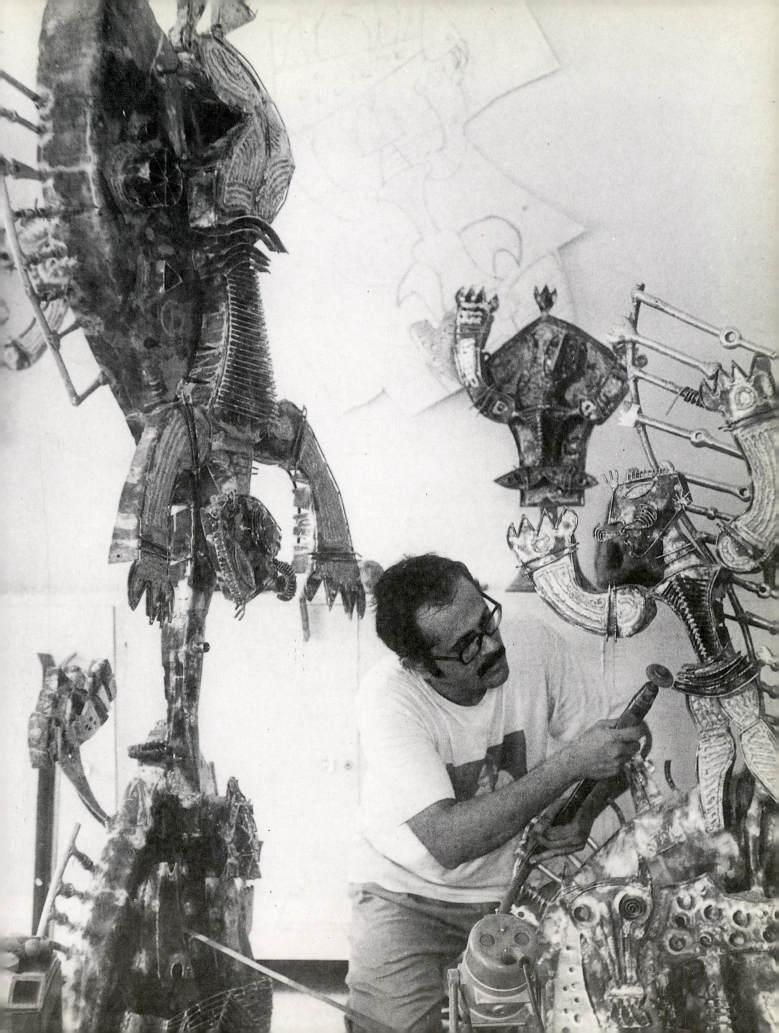

# S. Nandagopal

The trapezoidal silhouette of the large free-standing sculpture hits you as a mass. As you near it, small fish-like loops encircling it come into view and on closer inspection there are leaf-like shapes with eyes. They are a cluster of snake-heads. Nandagopal's work has a large presence and compels the viewer's attention. As one approaches the piece, it begins to reveal many surface details; details of crescents, small curves, triangles, and ovoid shapes move into view. It is an unusual visual language. The shapes work up the mind-set. Ancient motifs come alive and the excitement of the new begins to radiate. 'Serpent as Deity' is an early work by Nandagopal, the sculptor from Cholamandal. In silver-plated copper, the sculpture is currently at the National Gallery of Modern Art, New Delhi.

'*Gopuram*s [South Indian temple towers] set me off', says Nandagopal, explaining the basis of his inspiration. 'From a distance of some five miles or so, as you chant and approach it, it looms before you in its huge abstract form. As you move on, you discover the myriad figures that crowd the shape. They turn alive as you reach it, and as you pass under it, they completely overwhelm you.'

The experience would be routine for people in Tamil Nadu, the region of temples and *gopuram*s. But to attempt a contemporary sculptural expression of it would be to beg for an adventure at once with hoary tradition and contemporary sculptural practices. The many-sided argument which spirited such an adventure could very well be the story-line of this young sculptor's development.

It starts with being the son of the renowned painter, K.C.S. Paniker, a shy and withdrawn childhood at the Government College of Art and Crafts, Madras where his father was Principal, and thereafter out in the open at Cholamandal Artists' Village Paniker had founded. Nandagopal went to college, took a degree in physics, at the end of which he wondered briefly if he should become an engineer. He started commuting from Cholamandal to the Government College of Art and Crafts to learn to do ceramics with K.V.Haridasan, a senior artist friend of his. That initial exposure to craft,

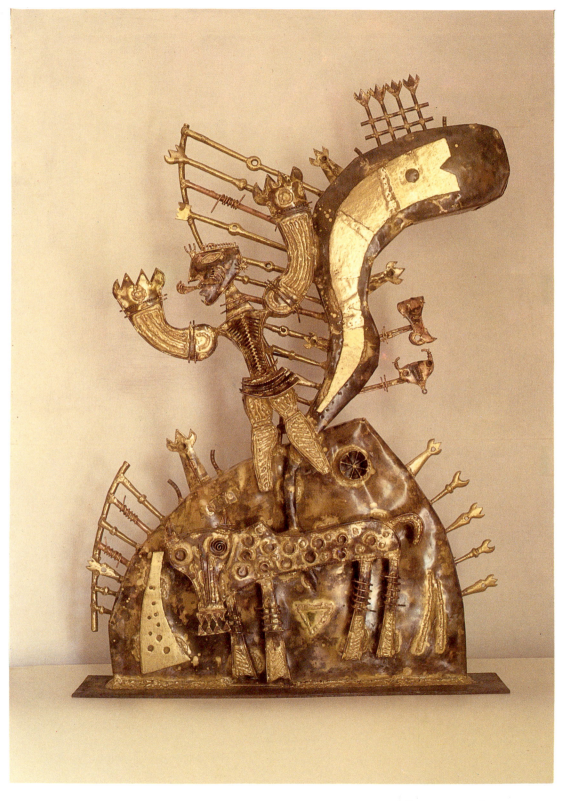

△ 'Memories of a Hero Stone-I'
Copper and Cast Brass
1993

▷ 'Vishnu'
  Welded Copper and Brass
  1981

together with the opportunity of watching his father paint at home, turned him around. He enrolled in the full-time five year course at the old College of Art and Crafts, Madras, in 1966 at the age of twenty. Recalls Nandagopal :

At the College, there was metal work, enamelling, and jewellery where I spent a lot of time. Crafts were also encouraged, with about thirty students being trained in leather work, goldsmithy, lacquer-work, and filigree. I tried all of them one after the other but soon found myself in the metal section under the influence of sculptor Janakiram. I found his sculpture striking. I became his student, but not in any textbook sense. He never taught me, but the sheer presence of the man was inspiring. Like many of the teachers in that place I had heard about, he never imposed anything on me. He just watched me grow up beside him.

He made his mark at the age of twenty-four when in 1970 he won the National Award. Along with him there were many other artists forging ahead in different parts of the country and that was further encouragement for him to let his impulse run in the direction his sculpture was taking at the time. From 'Serpent as Deity', with which he set his direction, he made a few references to the folk tradition, as in 'Deity on Animal' (1971) for instance, and moved off to larger and more studied expressions, like 'Tree' (1975), of which Phyllis Granoff, the Canadian critic wrote in 1980:

The branches of the tree unfold in three parallel gentle curves, a leaf at each end, reaching upwards. They are festooned with serpent-like shapes but these superimposed forms have finally achieved a visual significance equal to that of the objects as a whole and now exist in an organic unity with their background. As in the case of the ancient temple tower, *gopuram,* the viewer now participates in the dual vision process without hesitation or tension. The power of this new creative synthesis is undeniable. The tree, stretching heavenward with its crown penetrated by light and held firmly on the back of the earth-bound animal, is an awesome icon fashioned in a modern idiom for a modern celebrant. [*Art International*, Lugano, Switzerland, March/April 1980]

Works of sculptors abroad, especially that of Brancusi, Moore, and Noguchi excited him in his early days. But there was no question of waiting too long with any of them, when there was so much coming his way from what had been left behind in and around him by his immediate ancestors. 'Unless you are linked to the past you have nothing to go forward with', says the sculptor. 'Look at Ravi Shankar or M.S. Subbulakshmi. There has been no break with the past. But I am aware of the contemporary scene. Unless one knows what is happening in the rest of the world, how can you do anything original?'

It has not occurred to many that an individual's sheer workmanship can be

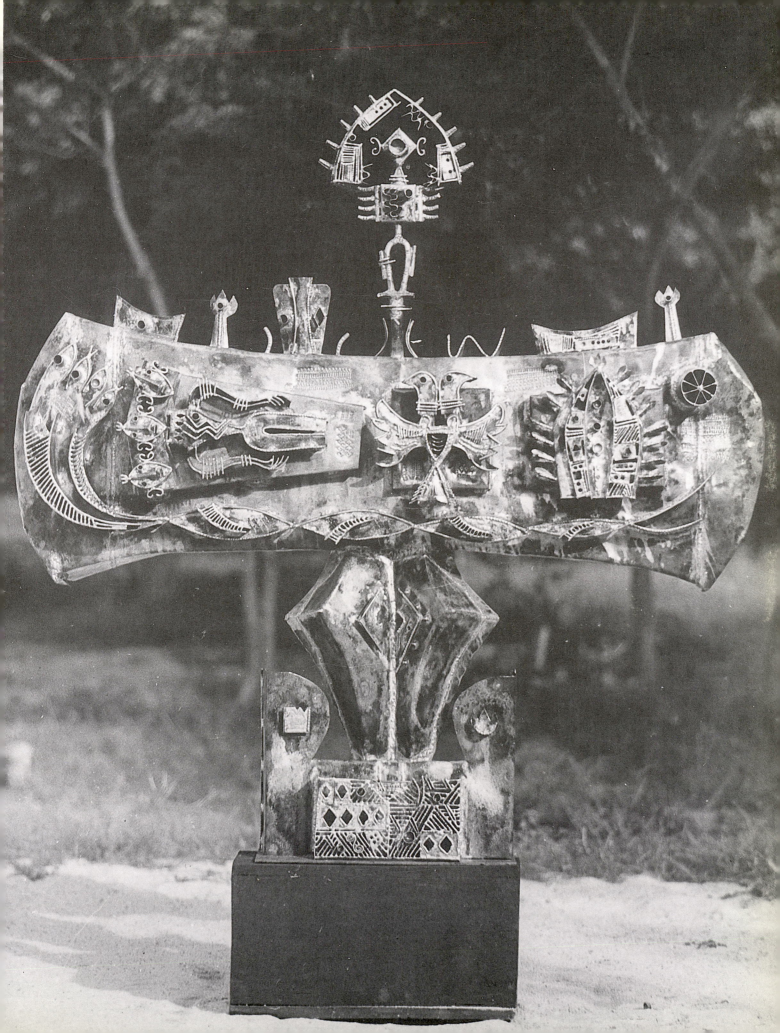

▽ 'Dancing Bird'
Copper, Brass and Enamels
1993
Collection : Mr. & Mrs. Joseph Alexander

▷ 'Bird'
Silver plated Copper
1980
Collection : Mahindra &
Mahindra Ltd

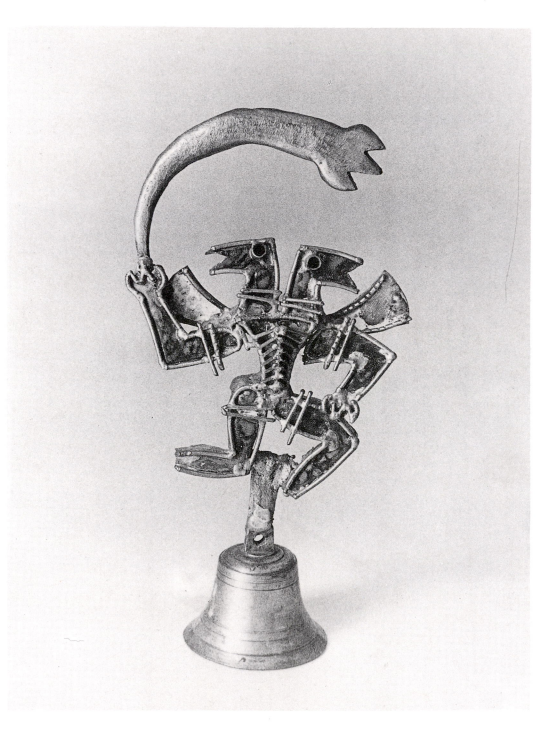

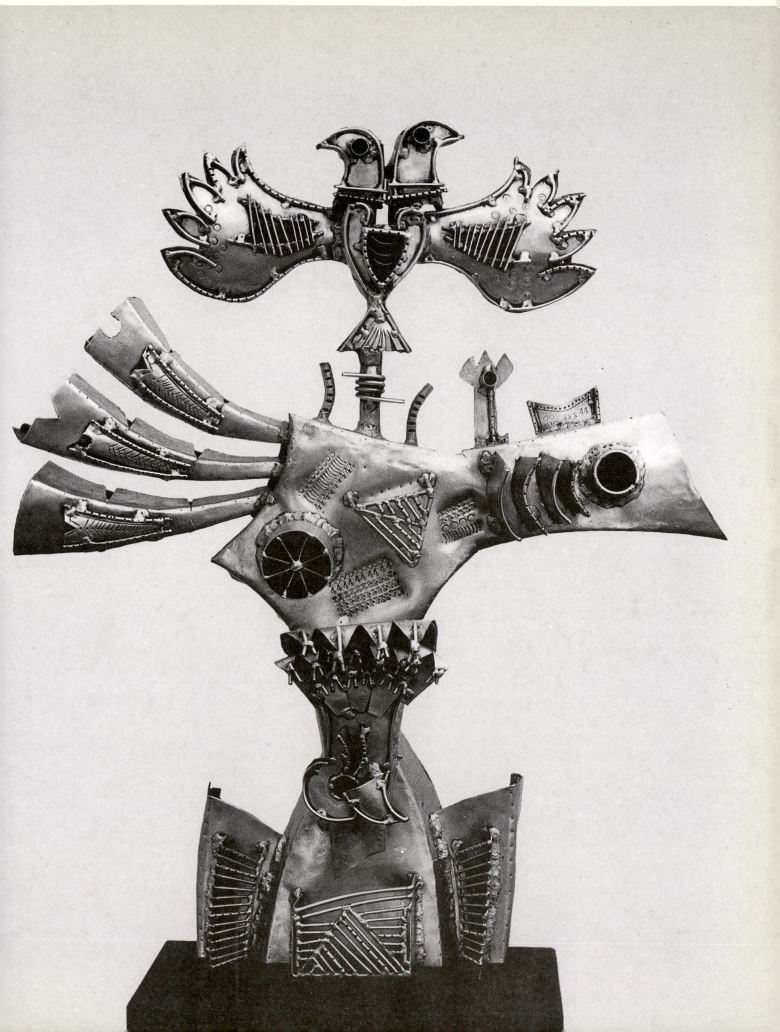

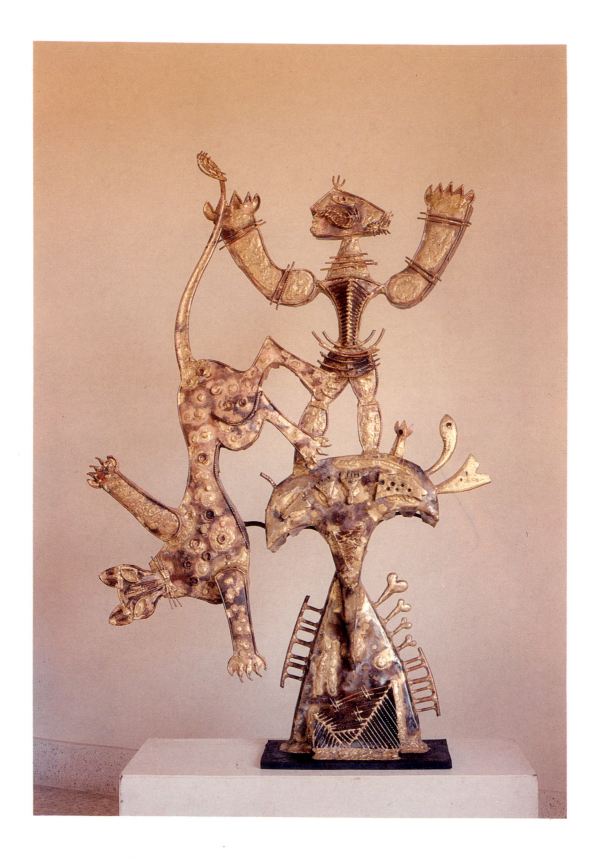

◁ 'Memories of a Hero Stone-2'
Copper and Cast Brass
1990
Collection : E.Alkazi,
Art Heritage Gallery, New Delhi.

the source of his originality. Consider his 'Shattered Image' (1975). It is a large phallic shape, covered by a large arch emanating from the shaft starting from the base; the entire work and its decorative extensions are filled with details. Wavy lines, fish-like shapes, the vocabulary of triangles, crescents, and curves have become a complex of proliferating forms vying with each other. The wealth of detail compels the viewer to pause and view the piece in a fantastic play of light as the many surfaces of metal gleam and glint. It is a sculpture where flat, broken, and concave surfaces interplay cleverly and blend to create a strong direct expression that is overpowering.

In the early years when Nandagopal was starting his artistic career, decisive moves had been made by sculptors in the country to turn sculpture away from the beaten path. Imaging, conceptualization, analysis, open form, etc had been done to death, one after another, and the move was on to clarify sculpture into just surface and detail. It had started with Dhanraj Bhagat in the early sixties and was carried forward by Janakiram. When Nandagopal worked it further, it attained a far greater clarity and vigour than Bhagat or Janakiram had thought possible in their attempts. In his highly crafted sculpture in flat metal, complete with its wealth of detail, he succeeded in welding into one whole the tradition of indigenous craftsmanship and contemporary design to make a frontal assault on the senses.

'It is not necessary to imitate in sculpture the three dimensionality that we sense in our experience of the ordinary world. One can bring it all to the surface and lay it flat in a spread. This is frontality. And it is a technique. There is nothing religious about it. No iconic value. It does not ask the viewer to go round it or to box it in. It is perforated sheet metal, sometimes with light from behind, with nothing at all at the back of it, nothing at all', explains Nandagopal.

The technique served extremely well in his attempts to picture complex mythological and allegorical, figurations of mysterious being. In 'Koorma-Tortoise as Deity' (1978) and a series of sculptures with the tortoise as motif, he tried to picture the whole myth of the *Koorma Avatar* of Vishnu churning the ocean. It was part of his narration in several sculptures of the cosmic figure of creation passing through time in the great epochal sequence. The technique of frontal presentation was stretched to the extreme in these works, as one would expect. But he enhanced it by avoiding symmetry or anything else that might suggest closure and achieved a wonderfully open form which could radiate freely in anyone's vision of it. Such a form can nourish a great deal of lyricism without any awkwardness, as he demon-

▽ 'Deity'
Welded Copper and Brass
1970

▷ 'Ritual Image'
Silver plated Copper
1978
Collection : National Gallery of
Modern Art, New Delhi

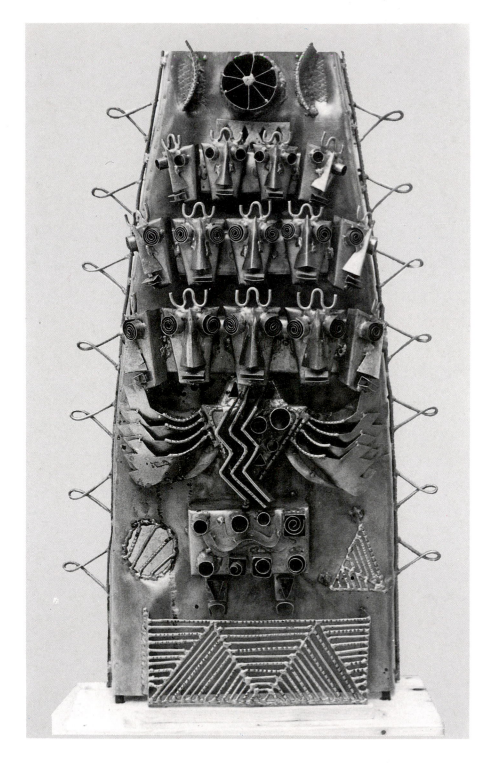

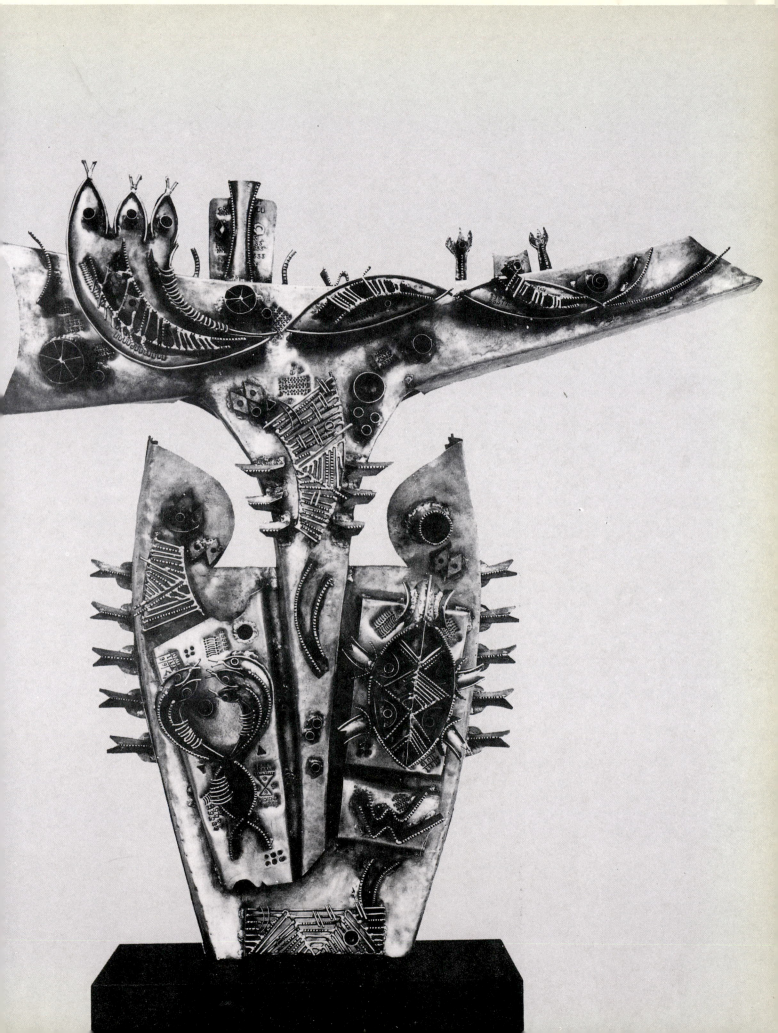

strated in a series of Krishnas he did on bell-tops. There was a feeling of grace and poetry in the sheer sweep of the metal in these sculptures, with the bells summoning the cows home at dusk. 'The total effect', said Mulk Raj Anand, reacting to his works, 'is to create a restlessness beyond the supine images before which the orthodox burn incense. Beneath the outer form one can see the shadows of delirium of the human soul.'

In 'Ritual Image' (1978), his work tried to reach a new equation. Its asymmetrical structure arising out of the large base of a balance was a study of depth, surface, and line. For him, it was an experiment in which 'I wanted to see the changes I could try with the fulcrum and see how much weight could be taken at one end. I also wanted to see how far I could stretch the axis. Earlier, my pieces had one shape and also no movement. With this piece a lot of asymmetry came in. This piece has a tail that rises in the sky as if tracing the line of a blazing comet'. Following this were pieces like 'Memory of a Hero-Stone' (1985) and 'Garuda' (1986), where the movement on the sculpture becomes more pronounced. Large sweeps of sheet metal come alive with patterned details. The double-headed animals, the fishes, bird-like forms all cohere to make the viewer sense a feeling of exhilaration in the sculpture. From the early eighties one can see the sculptor trying to bring together his philosophy of movement and the language of detail inspired by the strong craft tradition.

As in a South Indian temple, a subtle architectural sense patterns the wealth of rhythm that animate, permeate his sculpture. Do the asymmetries have an inner resonance? They must have, otherwise he would not be able to manage them as sensitively as he does. As in music, his work points to a basic core of rhythmic measures which determine its pulse. His new work has enamelling which, overall, give out a mysterious illumination. Yellow, blue, and sindoor red; monkeys trapeze off trees, birds flit, and Ganeshas sit in benign blessing. But soon enough, he finds himself reverting to pure metal. With the wealth of shades offered to him by copper and brass, there is once again a sense of a return to the basics.

In his studio a large mural is in progress. Dancers, singers, and performers form a long procession in cardboard. Nandagopal starts with a drawing, proceeds to replicate the piece on card, and then works with sheet metal welding, brazing, beating, and stamping the work all over with his very personal metaphors. After this the piece is thoroughly cleaned with acids and the patina level is achieved to his satisfaction. Then he covers it with acrylic spray that captures the patina permanently. Though he has done many large

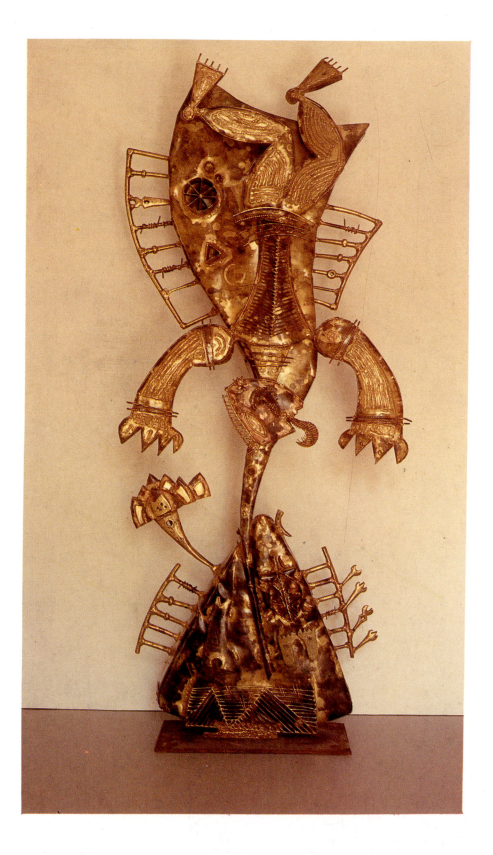

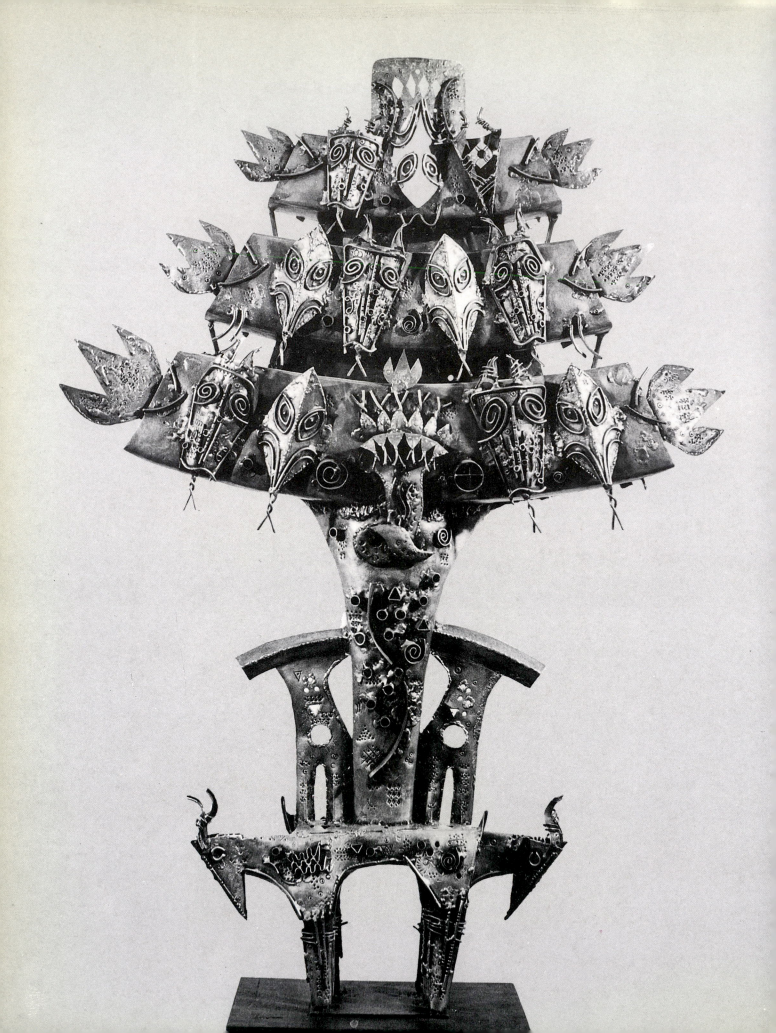

'Tree'
Silver plated Copper
1975
Collection : Rev. Heine, Berlin

'Man and Animal'
Copper, Brass, and Bell-Metal
1993

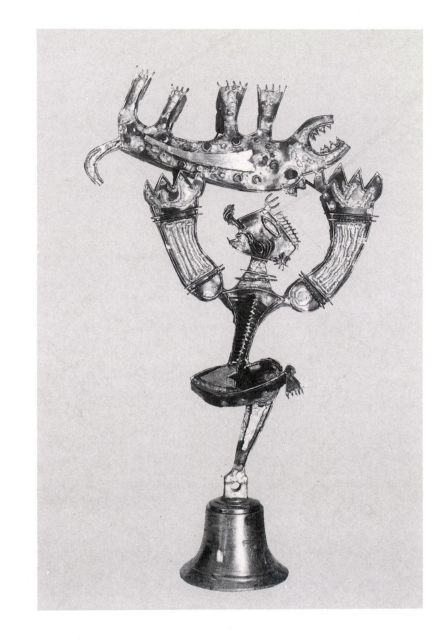

murals and commissioned works, he has yet to find a patron of the non-interfering kind, barring the Sri Lankan architect Geoffrey Bawa, who showed him the space and asked him to fill it up, without wanting to see the work till it was complete.

'I did have a complex about my famous father: I didn't want to use his name to get any leverage for myself and yet I feared that his towering personality and achievement, like the proverbial banyan tree, might not allow me or anyone else to grow...', confides Nandagopal, and adds with disarming candour, 'of course, I now realize that my anxiety was completely baseless. I am in my mid-forties and I must admit that some recognition has come my

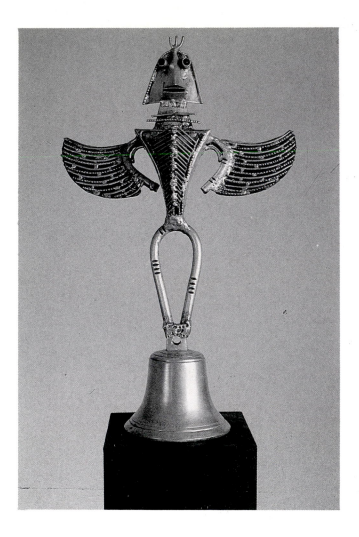

'Garuda'
Silver plated Copper
1985
Collection : Arpana Caur

way. But I feel that there is much more to be attempted and accomplished along the lines I have progressed so far. I cannot rest with what I have been able to do. My personal philosophy? Well, I do not subscribe to any hide-bound set of religious beliefs, though I am a Hindu and happy to be in the capacious fold of that way of life. My attitude to life is reverential rather than religious, and I feel indebted to the great myths, legends, allegories, and for-mulations that religion has afforded me.'

Over the years Indian sculptors have had to work with the pictorial aspect, often translating that into three-dimensional objects of great beauty. Nandagopal has successfully moved through the threshold of that pictorial tradition to come into the courtyard of its hallowed premises and awaiting a vision of his own to bear him further on into it. An inspiration that could mo-tivate a whole new generation of sculptors, inspired, as he was, by the modern sculptural thinking and the genius of native craft. For many years

now, the post-Independence art movement has tried to probe the indigenous tradition for some title to relevance and authenticity, but very few artists have succeeded in doing so. Nandagopal, with his brilliantly successful synthesis of 'art, tradition, and technology', has been able to bring out something of its genius and that has, in his case, turned out to be surprisingly contemporary, lively, and at the same time infused with rare feeling.

<div style="text-align: right">Ranvir Shah</div>

## NANDAGOPAL

*1946*   *born in Bangalore*

*1965*   *becomes a life member of Cholamandal Artists' Village, Madras*

*1966*   *graduates with a degree in Physics from Loyola College, Madras*

*1970*   *National Award of Lalit Kala Akademi, New Delhi*

*1971*   *receives a first class Diploma in Fine Arts from the Government College of Art and Crafts, Madras*

*1976*   *13th Middleheim Open-air Sculpture exhibtion, Antwerp, Belgium*

*1978*   *National Award of Lalit Kala Akademi, New Delhi; Gold Medal at the 4th International Triennale, New Delhi*

*1980*   *Homi Bhabha Fellowship, British Council Travel Grant; Travels in Europe and the United States; travelling exhibition of the National Gallery of Modern Art in Teheran, Moscow, and East European countries; Indian Section at Fukuoka Museum, Japan*

*1989*   *serves on the Henry Moore Foundation Fellowship Committee*

*1990*   *Senior Fellowship conferred for two years by the Government of India*

*1991*   *'The Madras Metaphor' exhibition organized by Ebrahim Alkazi at Art Heritage gallery, New Delhi*

*1992*   *nominated by the Government of India to serve on the purchase committee of the National Gallery of Modern Art, New Delhi*